the photographer's guide to the
Everglades

Where to Find Perfect Shots and How to Take Them

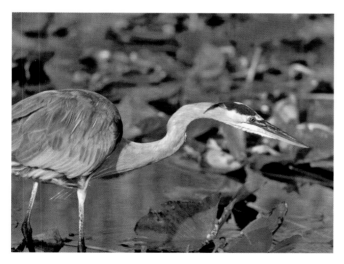

M. Timothy O'Keefe

THE COUNTRYMAN PRESS
WOODSTOCK, VERMONT

The Photographer's Guide to the Everglades
ISBN 978-0-88150-865-9

Maps by Paul Woodward, © The Countryman Press
Book design and composition by S. E. Livingston

Published by The Countryman Press,
P.O. Box 748, Woodstock, VT 05091

Distributed by W. W. Norton & Company, Inc.,
500 Fifth Avenue, New York, NY 10110

Printed in China

10 9 8 7 6 5 4 3 2 1

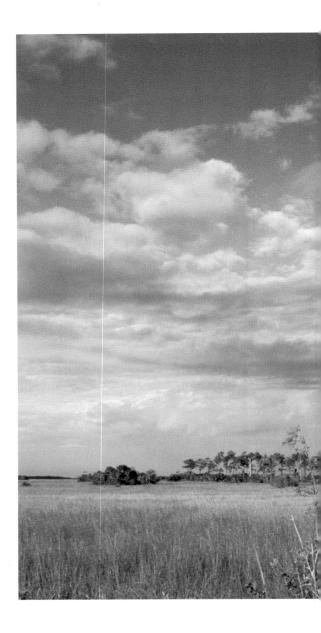

Title Page: Great Blue Heron
Right: Saw grass and twisted pine tree,
Everglades National Park

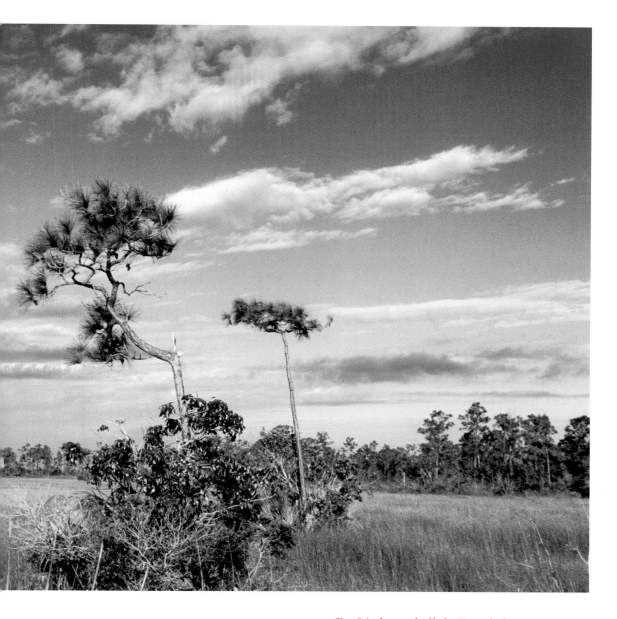

*For Linda, and all the Everglades mosquitoes
we have battled together.*

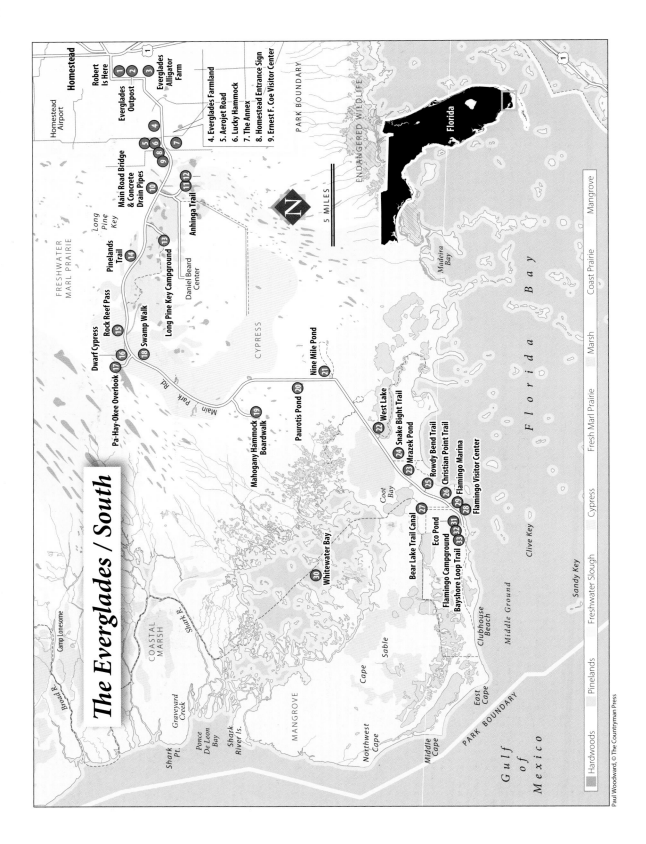

The Everglades / South

Homestead

Homestead Airport

Robert Is Here

1. Everglades Outpost
2. Everglades Alligator Farm

4. Everglades Farmland
5. Aerojet Road
6. Lucky Hammock
7. The Annex
8. Homestead Entrance Sign
9. Ernest F. Coe Visitor Center

PARK BOUNDARY

Main Road Bridge & Concrete Drain Pipes

Anhinga Trail

Long Pine Key

Pinelands Trail

Daniel Beard Center

FRESHWATER MARL PRAIRIE

Long Pine Key Campground

Dwarf Cypress

Rock Reef Pass

Swamp Walk

Pa-Hay-Okee Overlook

CYPRESS

Nine Mile Pond

Main Park Rd.

Paurotis Pond

Mahogany Hammock Boardwalk

West Lake

Snake Bight Trail

Mrazek Pond

Rowdy Bend Trail

Christian Point Trail

Flamingo Marina

Flamingo Visitor Center

Whitewater Bay

Coot Bay

Bear Lake Trail Canal

Eco Pond

Flamingo Campground

Bayshore Loop Trail

ENDANGERED WILDLIFE

Florida

Florida Bay

Madeira Bay

Clive Key

Sandy Key

Middle Ground

Coastal Prairie

Fresh Marl Prairie

COASTAL MARSH

Graveyard Creek

Shark Pt.

Ponce De Leon Bay

Shark R.

Shark River Is.

Camp Lonesome

Broad R.

MANGROVE

Cape Sable

Northwest Cape

Middle Cape

Cape

East Cape

Clubhouse Beach

PARK BOUNDARY

Gulf of Mexico

N

5 MILES

Hardwoods | Pinelands | Cypress | Marsh | Mangrove

Freshwater Slough

Paul Woodward, © The Countryman Press

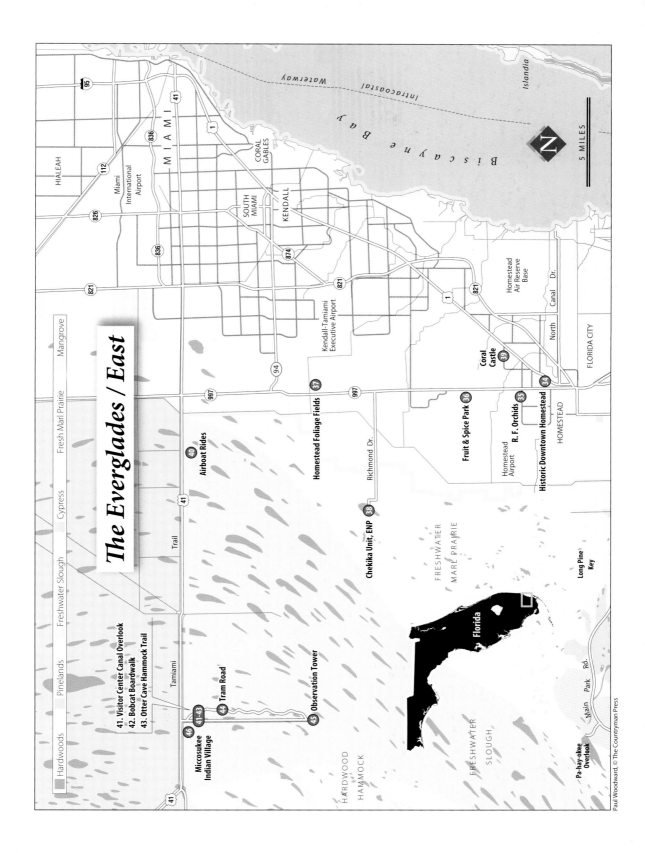

The Everglades / East

Hardwoods | Pinelands | Freshwater Slough | Cypress | Fresh Marl Prairie | Mangrove

41. Visitor Center Canal Overlook
42. Bobcat Boardwalk
43. Otter Cave Hammock Trail

46 Miccosukee Indian Village
41-43
44 Tram Road
45 Observation Tower

40 Airboat Rides

38 Chekika Unit, ENP

37 Homestead Foliage Fields

36 Fruit & Spice Park

Coral Castle 39

35 R. F. Orchids

34 Historic Downtown Homestead

HOMESTEAD

Homestead Airport

Richmond Dr.

FLORIDA CITY

Homestead Air Reserve Base

North Canal Dr.

Canal Dr.

FRESHWATER MARL PRAIRIE

Long Pine Key

FRESHWATER SLOUGH

Pa-hay-okee Overlook

Main Park Rd.

HARDWOOD HAMMOCK

Florida

Tamiami

Trail

HIALEAH

MIAMI

Miami International Airport

CORAL GABLES

SOUTH MIAMI

KENDALL

Kendall-Tamiami Executive Airport

Biscayne Bay

Intracoastal Waterway

Islandia

N

5 MILES

Paul Woodward, © The Countryman Press

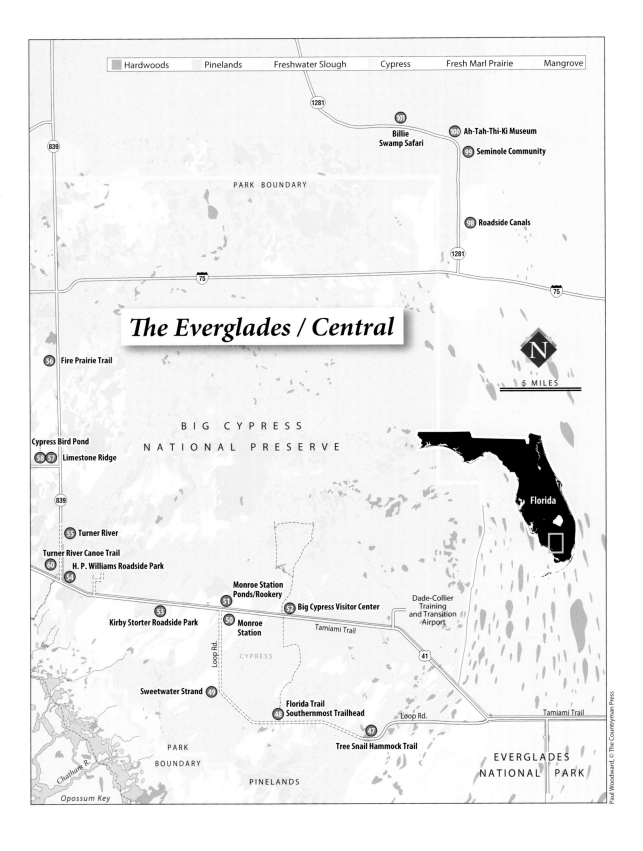

Hardwoods Pinelands Freshwater Slough Cypress Fresh Marl Prairie Mangrove

1281

Billie
Swamp Safari

101

100 Ah-Tah-Thi-Ki Museum
99 Seminole Community

839

PARK BOUNDARY

98 Roadside Canals

1281

75

The Everglades / Central

N

5 MILES

56 Fire Prairie Trail

BIG CYPRESS

NATIONAL PRESERVE

Cypress Bird Pond

58 57 Limestone Ridge

Florida

839

55 Turner River

Turner River Canoe Trail

60

H. P. Williams Roadside Park

54

Monroe Station
Ponds/Rookery

51

52 Big Cypress Visitor Center

53

Dade-Collier
Training
and Transition
Airport

Kirby Storter Roadside Park

50 Monroe
Station

Tamiami Trail

CYPRESS

41

Loop Rd.

Sweetwater Strand 49

Florida Trail
48 Southernmost Trailhead

Loop Rd.

Tamiami Trail

47

Tree Snail Hammock Trail

EVERGLADES

PARK

NATIONAL PARK

BOUNDARY

Chatham R.

PINELANDS

Opossum Key

Paul Woodward, © The Countryman Press

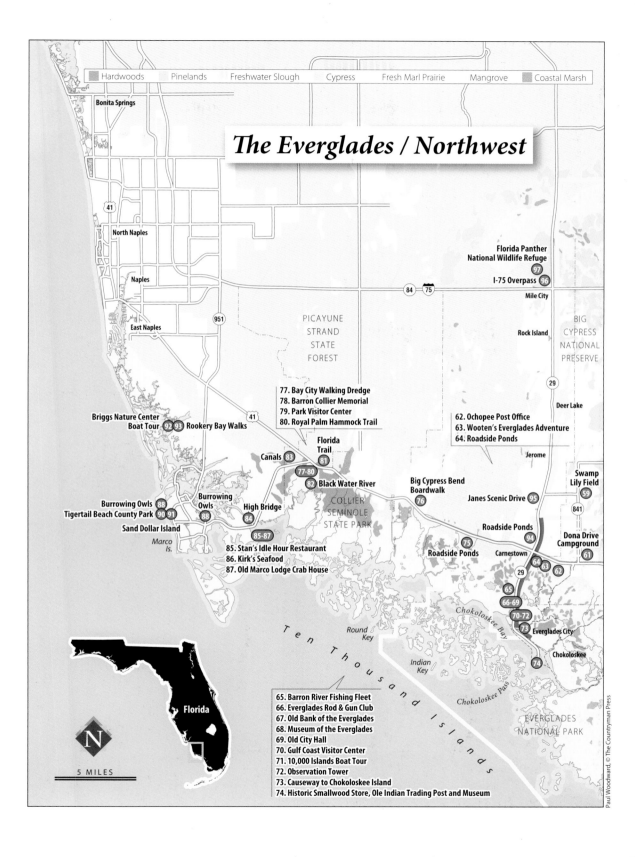

The Everglades / Northwest

Hardwoods Pinelands Freshwater Slough Cypress Fresh Marl Prairie Mangrove Coastal Marsh

Bonita Springs

North Naples

Naples

East Naples

PICAYUNE STRAND STATE FOREST

Florida Panther National Wildlife Refuge 97
I-75 Overpass 96

Mile City

BIG CYPRESS NATIONAL PRESERVE

Rock Island

Deer Lake

77. Bay City Walking Dredge
78. Barron Collier Memorial
79. Park Visitor Center
80. Royal Palm Hammock Trail

62. Ochopee Post Office
63. Wooten's Everglades Adventure
64. Roadside Ponds

Jerome

Briggs Nature Center
Boat Tour 92 93 Rookery Bay Walks

Florida Trail 81

Canals 83

77-80

82 Black Water River

COLLIER SEMINOLE STATE PARK

Big Cypress Bend Boardwalk 76

Janes Scenic Drive 95

Swamp Lily Field 59

841

Burrowing Owls 88
Tigertail Beach County Park 90 91
Sand Dollar Island

Burrowing Owls 88

Burrowing Owls 88

High Bridge 84

Roadside Ponds 94

Dona Drive Campground 61

Roadside Ponds 75

Roadside Ponds

Carnestown

64 63 62
29
65
66-69
70-72
73 Everglades City

Chokoloskee

Marco Is.

85-87

85. Stan's Idle Hour Restaurant
86. Kirk's Seafood
87. Old Marco Lodge Crab House

Ten Thousand Islands

Round Key

Indian Key

Chokoloskee Bay

Chokoloskee Pass

EVERGLADES NATIONAL PARK

Florida

N

5 MILES

65. Barron River Fishing Fleet
66. Everglades Rod & Gun Club
67. Old Bank of the Everglades
68. Museum of the Everglades
69. Old City Hall
70. Gulf Coast Visitor Center
71. 10,000 Islands Boat Tour
72. Observation Tower
73. Causeway to Chokoloskee Island
74. Historic Smallwood Store, Ole Indian Trading Post and Museum

Paul Woodward, © The Countryman Press

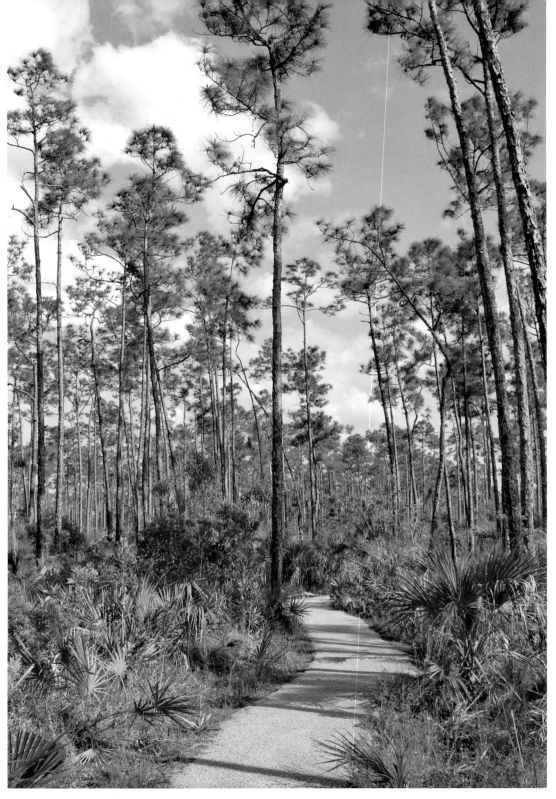

Everglades Pinelands Trail

Contents

Sprawling across Florida's southernmost tip is the legendary Everglades, the largest remaining subtropical wilderness in the continental United States. Due to its fame, many believe Everglades National Park encompasses all of the untamed Everglades. Far from it. Everglades National Park (1.5 million acres) and the adjoining Big Cypress National Preserve (716,000 acres) protect only about 20 percent of the area the Indians called *Pahayokee* (grassy waters).

In 1947, Marjory Stoneman Douglas turned the grassy waters into a waterway in her classic *River of Grass,* an environmental book so powerful it's credited with motivating President Harry Truman to create Everglades National Park (ENP) by an executive order. Indeed, technically the Everglades is located in the heart of a lazy river that advances only about a quarter of a mile a day.

Although ENP represents a tiny segment of the Everglades, over a million people a year visit to witness the profusion of bird and animal life in what is America's equivalent of an African game park. Many animals, especially wading birds, are accustomed to seeing three-eyed humans (that third eye being a camera lens), so with the right approach, you'll find you can draw pretty close to many of your subjects, including the American alligators, which litter the Everglades like fallen logs. Even the endangered American saltwater crocodiles, which seemed headed toward extinction but have made a remarkable return, are an almost certain photo subject for the first time in decades, if you know when, where, and how to look. That's where this guide should come in handy.

To photograph successfully in the Everglades, timing is critical. Birds and animals are

American bald eagle

most easily found during certain seasons and are annoyingly scarce at other times. Further, the photographic conditions are tougher here than in most of the United States. Because the Everglades is one of the nation's southernmost points, the light here tends to be hotter than elsewhere, virtually glaring out details on most objects during midday.

I was first awed by this challenging semi-tropical landscape as a teenage tourist from Virginia. It wasn't too long afterward that I migrated to the state. Now, after more than three decades of Everglades trips, I still feel the same anticipation I felt on that long ago first visit. I

always leave impressed, sometimes downright overwhelmed if the scene and light come together perfectly, as they often do at the most unexpected times. As a result, I've been fortunate enough to have some of my Glades images appear internationally in books, calendars, magazines, and on TV.

I hope that sharing the following places and the techniques that seem to work best for me will not only help you capture better images but also appreciate how the delicate ecosystem is able to produce such outstanding photographic opportunities. It's why I firmly believe knowing the natural life cycle of the Everglades is the best way to ensure your visit is as successful as it can be.

Understanding the Region

The Everglades primarily is a shallow plain of saw grass growing in water only 6 inches deep. This blanket of water has been likened to a tropical, primeval soup of algae and bacteria. Unappetizing as that may sound, it nourishes snakes, turtles, fish, and insects, which in turn feed the incredibly rich population of birds, alligators, and crocodiles.

Until the 20th century, when a maze of canals was installed to drain the wetlands so the population could increase, the most important water source for the Everglades always had been Lake Okeechobee, well north of the park. Each summer, Okeechobee (second-largest fresh water lake in the continental United States) would overflow and send a sheet of water 50 to 70 miles wide over the landscape. The water advanced about 100 feet a day, thoroughly watering and flushing the saw grass, eventually reaching the mangrove estuaries on the Gulf of Mexico.

The annual flood was followed by a six-month dry season. Birds and animals patterned their lives on this cycle. During the wet summer season fish spread throughout the region, which in turn dispersed the birds and alligators over a vast and often impenetrable territory. The mosquito population was also at its most impressive and terrifying density then.

Photographing in the Everglades today is based on this ages-old cyclical water flow. In November the rainy season usually ends and the saw grass sea starts to dry up. Fish move to the deeper holes and canals, usually in mid-December or early January. Birds and alligators take up residence in these same places. By the end of February the Everglades is as dry as it will be that particular year and the annual harvest of fish is at its height. This is the time every photographer wants to be in the Glades. The mosquito population also is usually at its smallest so there is often no need for bug spray.

Winter may be the most opportune time for birding, but summer is orchid season, and nowhere else in the U.S. has more wild orchids than the Everglades region. Further, frolicking dolphins and the endangered manatee are most active in the coastal waters of the Everglades in summer, with plenty of boat rides available to find them.

Like photographing dramatic weather? Florida is the lightning capital of North America, and most summer afternoons you can expect a thunderstorm whenever the wind blows across the Everglades.

Photographically, there truly isn't a bad season in the Everglades. Much depends on which subjects appeal to you, animals (winter) or landscapes (anytime), and also on your tolerance for heat, humidity, and biting mosquitoes.

Whatever time of year you choose, you can count on many memorable photographic opportunities with the aid of this guide.

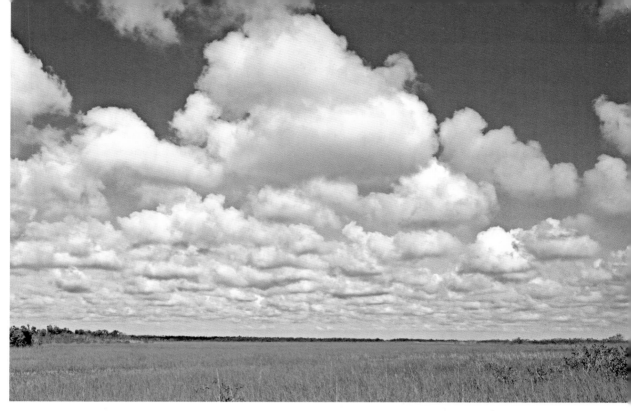

Building clouds provide amazing depth of field

Using This Book

What to Expect

Thousands of years ago, Florida's Everglades was literally at the bottom of the sea, which accounts for its amazingly flat, horizontal landscape. At first, this level terrain with its lack of dramatic topography may appear monotonous, but give it time to work its charm on you as it does on most photographers. Like the grassy plains of Africa, the Everglades transform remarkably throughout the day according to the light.

Yet it will be the animals, particularly the wading birds, that provide endless fascinating hours as you photograph their varied series of behaviors and keep improving on how to capture their portraits.

Photography in the Everglades is, for the most part, surprisingly relaxed. In most places you need walk only a short distance from your car to begin shooting. Far more often than you can anticipate, you'll be shooting out of your vehicle window to avoid stepping outside and disturbing your subject.

Unless you're shooting professionally, you may be traveling with children, one reason roadside attractions featuring airboat rides or native Indian villages number among the photo stops. If you take an airboat ride, have earplugs on hand. These noisy, flat-bottomed, shallow

draft boats powered by airplane propellers at the stern are by far the most efficient vessels for penetrating the sea of grass.

Long before theme parks, roadside attractions in the Everglades were among the favorite stops for Florida tourists. So don't bypass the Miccosukee Indian Village near Shark Valley. Yes, the recreation may be a little hokey, but if you want iconic images of an Indian wrestling an alligator in good sunlight, this site is a must.

Possible Hazards

The purpose of this list is to help ensure none of the following ever do pose a genuine hazard.

Lightning: Florida is one of the world's lightning capitals; state statistics say you're more likely to be zapped by lightning than fatally bitten by a snake. A towering thunderhead is a dead giveaway that a thunderstorm is in the vicinity. Take refuge in your vehicle or inside a building. Never stay out in the open or stand under trees.

Dehydration: It's easy to lose a lot of liquid perspiring in the high humidity of the Everglades. Not replacing it will make you feel tired and lousy. Thirst, dry lips, and a parched throat all are signs of dehydration. You need about two weeks to adjust to Florida's high humidity. Maintain your energy by consuming water and sports drinks even when you don't feel thirsty. Alcohol and colas contribute to dehydration.

Sunburn: The sun is far more intense in Florida than anywhere else in the continental U.S., except for extremely high elevations. Wear a water-resistant sun block (SPF 25–30) and possibly a sun block on your lips. The best protection of all is a long-sleeved shirt and long pants and a broad-brimmed hat. In the event of sunburn, pure aloe gel usually works well.

Snakes: Florida has a larger snake population than any other state, but snakes are rarely a problem if you stick to the trails. If a snake does bite someone, take the person to a hospital immediately (or call 911 if you're in a remote area). Don't cut the skin to suck out the venom. Write down a description of the snake for medics.

Saw grass: In the Everglades, saw grass spans the horizon for 50 to 70 miles east to west and another 100 miles north. Please note the term *saw* in saw grass, something better to learn here than by touch.

Rabid raccoons: Avoid animals that are overly friendly or aggressive, seem to have no fear of humans, or appear bedraggled and wobbly on their feet.

Alligators: Look carefully as you walk. Gators blend in with the scenery amazingly well, and you want to stay at least 15 feet away from them, the distance recommended by the National Park Service. Personally, I think that's a little too close and I always use a telephoto lens. Alligators normally are not aggressive unless they've been fed by people or you happen to be walking a small dog (a favorite alligator snack). An alligator typically lets you know if you're too close by opening its mouth and hissing at you. Never be fooled by any alligator's lethargic appearance. It probably can run faster than you. Scientists agree they can sprint at 15 mph.

Annoyances

Mosquitoes: Florida has 67 species of mosquitoes. The easiest way to avoid them is to wear long pants and long-sleeved shirts and use insect repellent with DEET.

No-see-ums: Normally only beach hikers at sunrise and sunset need to worry about no-see-ums. Along with a DEET-based spray, long pants, and shoes and socks are the best protection.

Photographic Realities

You can always count on finding El Capitan in Yosemite or a fishing village in Maine. The Everglades guarantees only three things: saw grass, water, and humidity. Sometimes Everglades photographers are disappointed when they fail to capture the images they imagined because the birds and alligators are scarce. That's usually because the person is there at the wrong time or in the wrong place or both. The purpose of this guide is to help make sure that doesn't happen to you.

Be forewarned: You may find yourself so captivated by the Everglades that you'll be back during the hottest summer days to photograph the myriad flowering orchids. You also might make important links with some full-time Everglades residents, a hardy breed proud of where they live. Take the time to get to know them and you'll learn they are amazingly generous in assisting visiting photographers.

Many like sharing their knowledge, providing the chance to take images you'd never get without their help. You could even end up with photos of a Florida panther, among the world's most endangered mammals. I did.

Florida's Everglades is America's last untamed frontier, one notably inhospitable to humans. For photographers, that is both its appeal and its challenge.

The Never-Ending Guidebook

This book is only the beginning of your Everglades photo journey. The companion website, www.FloridaWildlifeViewing.com (and its Everglades Photography section), will include material and photos that were impossible to include within these pages. The site also will contain updates whenever the current information changes.

This is one guidebook that will never go out of date.

Some of the most memorable Everglades photo moments come just after dark. Keep your camera and strobe ready at all times.

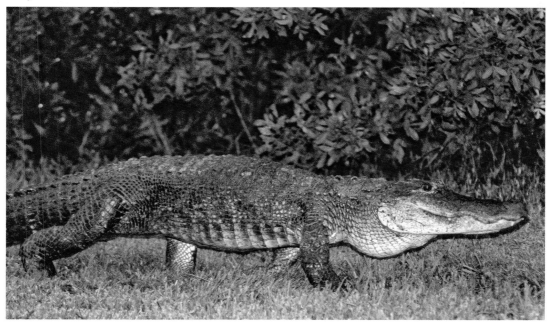

Anhinga Trail boardwalk

How I Photograph the Everglades

Although the Everglades offers impressive scenery, like most photographers I concentrate on wildlife, the birds, gators, and crocodiles. Landscapes may be secondary and subjects of opportunity but I'm always ready to stop and snap one of the region's impressive panoramas.

One reason wildlife is my main interest is the animals' amazing tolerance of photographers, undoubtedly because they see so many of us. Their acceptance of our presence is fundamental in capturing good images. Looking over my photographs, it's clear my best wildlife images in ENP usually were taken where animals lived with a constant stream of human traffic. The Anhinga Trail at Royal Palm Plaza, for instance,

is only a few miles from the park entrance and one of the most visited sites in the Glades.

At first this puzzled me, because I expected wild critters to avoid such human congestion. If their living conditions weren't so perfect they might. However, the deep canals bordering Anhinga Trail create ideal feeding for wading birds and alligators during the winter dry season. Despite scores of people strolling the designated path, this always is a reliable place for capturing animal portraits. In more remote regions, animals sometimes spook at the first glimpse of me. I'm a trespasser there, but at Anhinga Trail I'm only part of the moving scenery.

How to Approach Wildlife

Finding a good location is only step one in capturing memorable wildlife photos. You also need patience, dedication, and practice. I've spent as long as a week photographing on the Anhinga Trail, arriving before sunrise, taking a midday siesta, and then returning to stalk the same critters. Confinement to a single spot allowed me to discover where particular animals would be at certain times of day. Anhinga Trail residents have an amazing internal clock that I can almost set my watch by, particularly the cormorants, which start fishing in earnest in late morning.

Although many wild animals allow us to approach very close, respecting their personal space is essential. When we cross a boundary, they sound their alarms. Birds often signal we're intruding by ending their feeding and staring at us. Or they may become aggressive or skittish, dive-bomb us, or start circling overhead. Ignore a wading bird's warning signs and your photo subject may take flight.

Breach an alligator's territorial boundaries and you could find yourself in a greater predicament. Historically, alligator attacks are uncommon, but the occasional maverick does decide to harass or grab a person for no apparent reason. That's what we want to avoid.

Alligators are easy to underestimate. They have perfected the wolf-in-sheep's-clothing routine, insinuating themselves into a landscape, appearing somnambulant, totally innocent, uninterested in everything around them, while ingenuously maneuvering themselves within reach of a perched bird or a school of fish. Their attack is sometimes unexpected but always accomplished with terrifying speed and incredible brute power. Even veteran alligator wrestlers can't always predict how the animals will behave. Which is why most retire after losing a finger or thumb.

How do you know when you're too close to an alligator? As a warning, a gator typically will open its mouth and hiss at you. If you keep approaching, it will leave or charge. An alligator can sprint at least 15 mph; maybe as fast as 35 mph. Can you move that fast? ENP recommends at distance of at least 15 feet but that may not be enough: keep your distance!

Light—But Not Too Much

There's an old Beatles song titled "I'll Follow the Sun." Those words in a nutshell summarize photography in the Everglades, where the natural light varies tremendously in its intensity. Optimal shooting conditions are present both early and late, during the so-called golden hours just after sunrise and prior to sunset. Fortunately, these two times coincide with the periods wildlife tends to be most active.

This is how you know you're too close to a gator

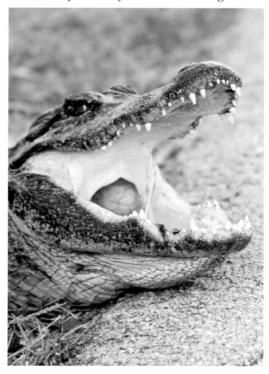

For photographers, the golden hours are a magical time, with the world bathed in a soft yellow hue. The slanting sun also highlights fine details on almost every kind of subject, such as an animal's individual hairs or feathers or the delicate filaments of a plant. Such features are washed out at midday but always prominent in soft, angled light. The principal shooting periods are the first three hours after sunrise and the first two before sunset, when the sun is also at an angle.

Digital cameras make it easy to photograph right up to sunset and beyond. I recommend a sturdy tripod for long lenses over 300mm, even those with an anti-shake mechanism. If you happen to carry along a small point-and-shoot camera with movie mode, you'll need a tripod for image stabilization when zooming in close to avoid having your video look like it was filmed during an earthquake. Quite often video cameras can record animal movements when brighter conditions are required for a still camera.

Daylight Strobing

Don't always photograph with sunlight over your shoulder. Experiment. Position the sun behind your subject to emphasize feather texture and animal fur and highlight the veins of a plant. Take it a step further by adding an external flash to pop out more details and colors of your backlit object. Using the TTL setting on your strobe, underexpose 2/3 of an f-stop, then experiment by bracketing. To bracket, take 3 photos, one using the camera's recommended settings, one intentionally underexposed, and

It was still pre-dawn when I flashed this great blue heron

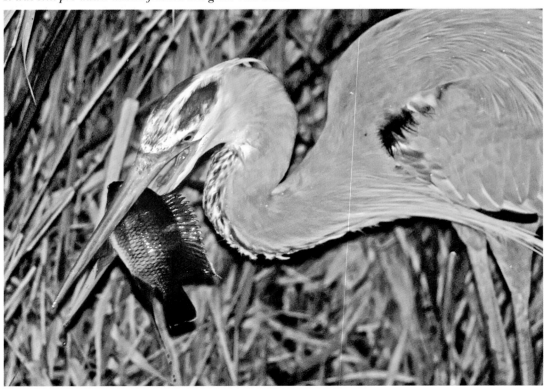

one intentionally overexposed. Many cameras have a bracketing feature that will do this automatically. Animals can get annoyed with all this man-made lightning and depart. Start your experiments with a rooted subject.

External strobes have many advantages over built-in pop-up flashes. They have increased flash range, faster recycle time, eliminate red eye, and don't create a hot spot in the middle of the picture. They can also be angled up to reduce harsh lighting, making them better for portraits and macro (close-up) photography.

Sunsets

The key to good sunset shots is not to shoot too soon. Here's my favorite technique for knowing when to start: I hold my fist at arm's length with my thumb pointed straight up and the bottom of my hand in line with the horizon. If the sun is above my thumb, it's too early for good silhouettes. Once the sun drops below my thumb tip, I start shooting.

Unfortunately some sunsets are just plain dull rather than bright. These can be salvaged with a light orange, yellow, or purple filter. Or you can deepen background color by underexposing between 1/3 and a full f-stop for the first 5 to 10 minutes after the sun disappears.

Be Prepared: The Need for Speed

To capture a running animal or an alligator lunging at a bird, your shutter speed needs to be at least 1/500 second. That means operating your camera on its "S" or speed priority function and dialing in your shutter speed. That's easy. The hard part is having enough light to operate at that speed. Thus, all the constant urging for using a tripod and an external flash.

Now the camera is set to go. Are you? In the Everglades, anytime, anywhere, you could en-

Carrying a flash on your camera is always a good idea

counter a good photo subject. Is your camera in easy reach? While driving I always have at least one camera (sometimes two) waiting atop the storage console beside me. Keeping my camera ready—without lens cap—is how I shot a bobcat that magically walked through the bushes to appear roadside.

Animal Close-ups: The Eye Has It

Before I press the shutter for an animal portrait, I ask how clearly I can see the critter's eye. If the eye isn't bright, I wait until the subject changes its position. Should it start shaking its head and appear not likely to calm down, I shoot a burst of images and hope I've been lucky.

If the animal is too much in the shade for the eye to stand out—a common problem with dark-skinned, dark-eyed alligators—I add flash. If the eye still isn't prominent, I delete the image. Any animal photo without a clearly visible eye is a mundane snapshot, not an image worth saving.

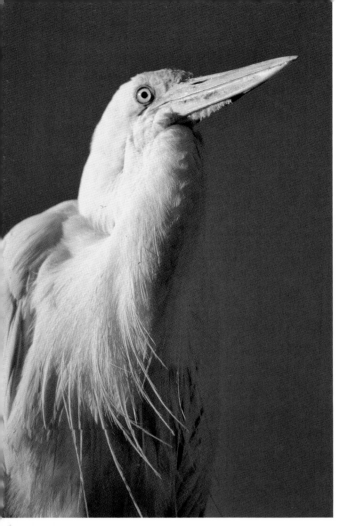

Vary your position so you're not always shooting down on your subject.

The importance of an animal's eye shouldn't be a surprise. With people, it's a long-held maxim that the eye is the window to a person's soul. So it is with wildlife, too. Perhaps more so, since the eye often reveals not only the essence but also the possible menace of a wild animal.

An important factor in capturing the eye is how you position yourself in relation to the animal. The easiest method is to view it sideways, since a profile almost automatically brings the head plus the entire body into focus. If you're forced to photograph the animal head on, eye-to-eye, remain concentrated on the eyes. It makes little difference if the nose or snout is soft as long as the animal's eyes are sharp, crisp, and clear

Point of View

Too many Everglades photos appear condescending because the camera is tilted down on the subject. In some circumstances, looking down is the only position to take. Yet this viewpoint also makes Everglades photos look too similar.

Whenever possible, I try to stay at eye level with my subject. That may mean crawling on my belly like a snake, with a waterproof nylon tarp beneath me when the ground is wet.

For another viewpoint, close-ups of strange-looking insects and plants are some of the best photo opportunities in Florida's swamplands. Unless a situation poses a problem (such as deep water) I like to use a wide-angle lens I can focus within a foot or so of my subject. Within that range, it's possible to capture life-size images, referred to as a reproduction rate of 1:1. It's also possible to achieve the same results using a telephoto lens on a tripod with your camera on "A" for aperture control, using a setting between 8 and 11 for good depth of field.

For taking close-ups of flowers and other stationary objects, if possible I'll use my widest-angle lens for better depth of field and sharper focus to show the subject's surroundings.

Equipment

Whether you're driving or walking, the most dramatic Everglades photos happen in the blink of an eye, faster than you can imagine. You must respond rapidly or miss the action entirely. That means staying mobile, on alert, with the ability instantly to point your camera

anywhere, very different considerations from landscape photography.

Keeping in mind the need to shoot fast action at 1/500 second, a 300mm lens is about as large as most people can handle without the aid of a tripod. Above 300mm, camera shake will blur the image, putting it out of focus, despite the ever increasing advances in digital lenses and cameras. Don't depend on any anti-shake, stabilizing device except a tripod.

I personally carry two camera bodies and four lenses: A 16mm fisheye is often the only way to obtain good details of overhanging trees or create an original way of capturing the Glades scenery. Also, a 12–24mm lens is useful for landscapes and plant and flower close-ups when there isn't time to set up a tripod.

My most used lens is an 18–200 because of its amazing versatility. It works well for the majority of wildlife subjects and doesn't require a tripod except in low light. For serious wildlife photography, I turn to my 80–400mm, but it's so heavy it requires a tripod except in bright daylight.

You can make any telephoto lens even "longer" by adding either a 2x or a 1.5x extender. A 2x extender, for instance, doubles the focal length of the lens, so a 300mm lens becomes a 600mm. Extenders come at a price: They take away one or two f-stops.

Filters

Although many claim Photoshop/Lightroom will provide all the colors you need, I still rely on the same colored glass filters I carried for film. Admittedly, except for sunsets/sunrises, I rarely use any of them except for a polarizing filter around water that allows me to "see through" the surface glare by rotating the filter. This is critical to show an alligator's legs under the surface but useless in most other situations. Unfortunately, a polarizing filter slows you down by two f-stops. Better to saturate your images in Photoshop/Lightroom. Using the "vibrance" tool blues up a sky as well as a polarizer without darkening detail.

Protection against heat, humidity, and rain

Unless the sky is bright blue when you take an extended leave from your vehicle, be prepared. Low dark clouds don't always mean rain, but the weather change can be amazingly fast.

Be prepared for closeups like this zebra longwing butterfly, designated the Florida state butterfly.

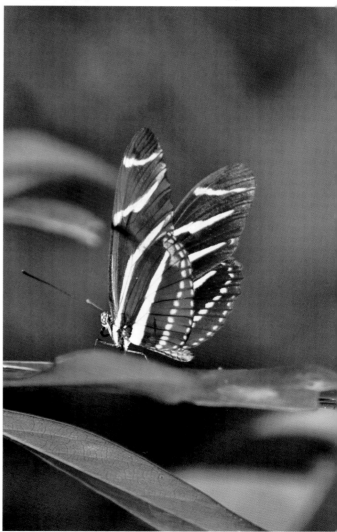

If weather conditions are uncertain, carry a plastic garbage bag to protect your camera and a large lawn garbage bag you can poke a hole through to wear as a poncho. To protect my camera bag, I use a thick trash compactor bag that's hard to tear.

Considering the heat and humidity, the best way to carry a variety of lenses and filters is a lightweight tropical photo vest to replace your camera bag. Anyone wearing a heavy cotton photo vest is marked as both a tourist and an amateur, in that order.

Personal Logistics

Because the Everglades covers such an immense region, I make a shoot list of subjects and where they're most likely to be found. Then I decide where to make motel reservations. Although quite a few roads crisscross the Everglades, this still is very much a wilderness area with lodging, fuel, and restaurant stops few and far between. In fact, campgrounds are the only places to stay in Everglades National Park or in the Big Cypress National Preserve.

Unless you're camping, the most convenient overnight locations are in Florida City near the Homestead entrance and Everglades City in the 10,000 Islands section of ENP. Shark Valley is in the middle of nowhere, with Everglades City the best base. In the peak winter season, accommodations are both more expensive and scarce—especially on weekends when anglers converge in the same areas.

While I enjoy camping, it's not something I do on a Glades photo trip when I rise before dawn and photograph until after sunset. All I want to do at the end of the day is download my images, microwave a pre-prepared meal, take a good hot shower, and collapse in a comfortable quiet bedroom with air conditioning (if needed).

Most Florida City and Everglades City motels offer both a small refrigerator and a microwave. Consider carefully how you want to spend your non-shooting hours. It makes all the difference in how much you enjoy the following day.

An extreme example of what to prepare for—rain and mosquitoes

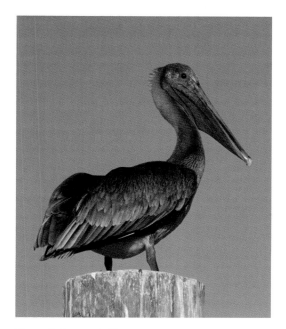

Juvenile brown pelican

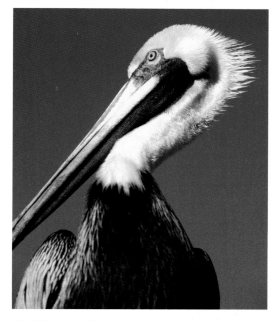

Adult brown pelican

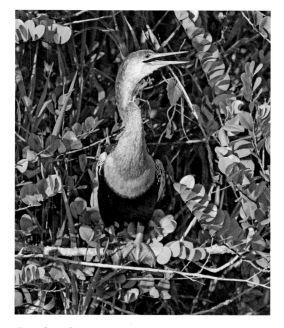

Female anhinga

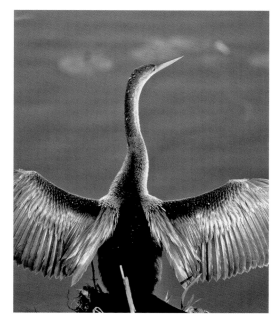

Male anhinga

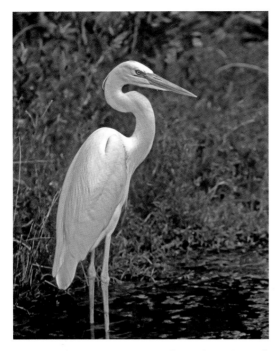

The great white heron is actually a white phase of the great blue heron.

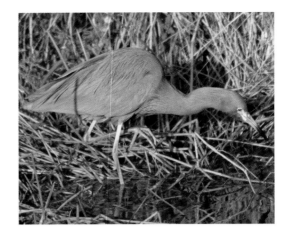

Little blue heron

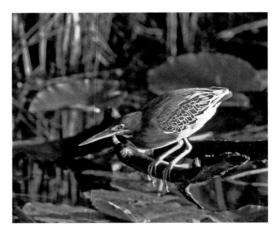

Green heron

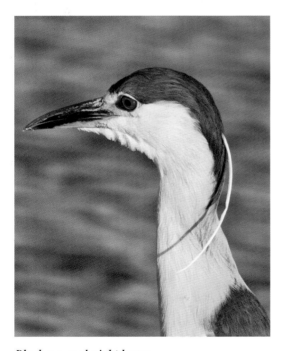

Black crowned night heron

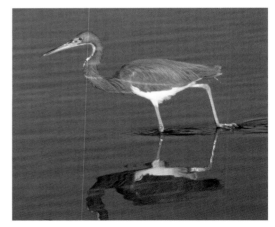

Tricolored heron

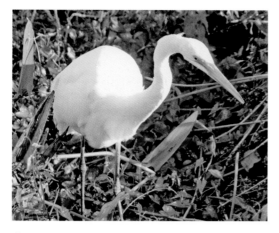

Great egret

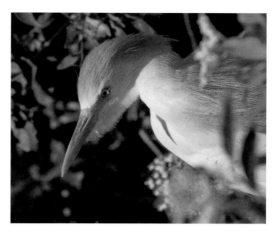

Breeding color of the cattle egret

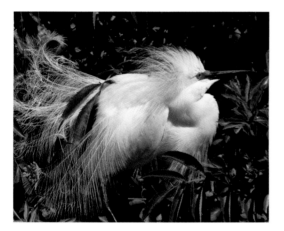

White breeding phase of the reddish egret

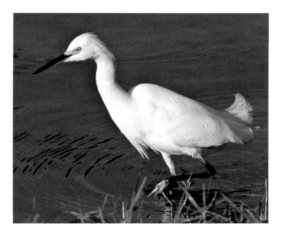

Snowy egret

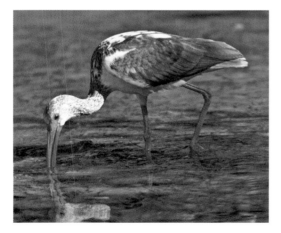

Immature white ibis

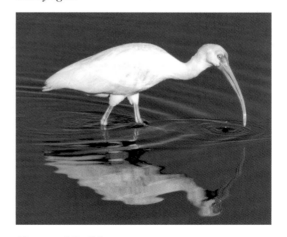

Mature white ibis

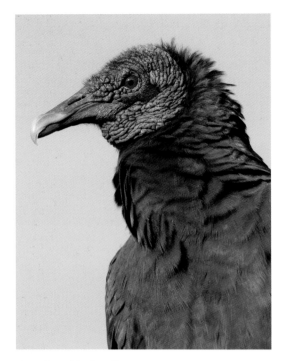

American black vulture

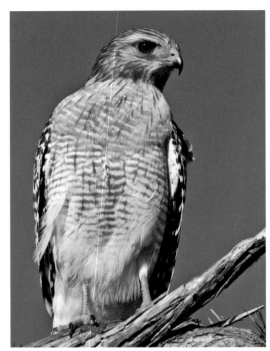

Red-shouldered hawk

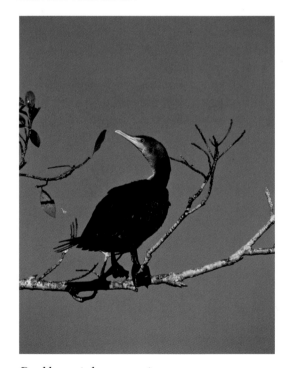

Double-crested cormorant

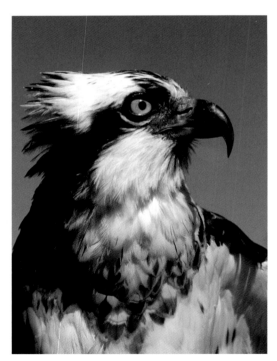

Osprey

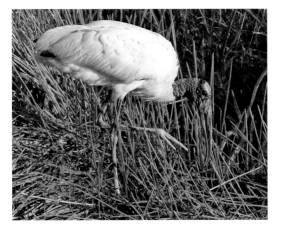

Everglades wood stork

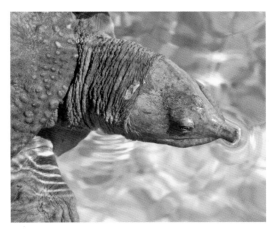

Florida soft-shell turtle

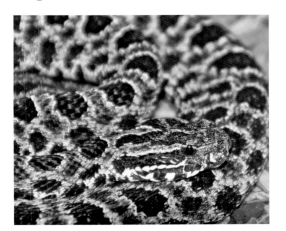

Diamondback rattlesnake

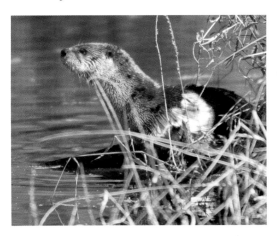

River otter

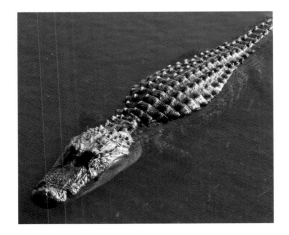

American alligator

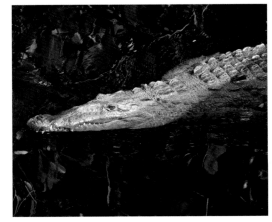

American saltwater crocodile

I. Homestead/Florida City to Everglades National Park

General Description: After leaving Florida City, much of the terrain turns into flat, open farmland that produces several crops of vegetables annually with a year-round growing season. This once-marshy region was made habitable through a series of drainage canals, some you'll see on the way to Everglades National Park (ENP). Besides farmland, you'll have the chance to stop at several longtime roadside attractions.

Directions: From Miami, go south on the Florida Turnpike (FL 821) until it ends at Florida City and merges with US 1. Go south on US 1 to the first traffic light. Turn right at the first traffic light onto Palm Drive (also FL 9336 and SW 344th Street). Follow signs to ENP.

Robert Is Here! (1)

Follow FL 9336 from Florida City to where it makes an abrupt left turn. Robert Is Here! will be on the right after the turn. What started as a cucumber stand in 1959 when Robert was only 6 years old has become an area landmark anyone who has been to ENP instantly recognizes. Shots of the slightly ramshackle fruit stand and purple martin birdhouses beside it are both worthwhile but the real prize is inside, the displays of seasonal tropical fruits difficult to find in such abundance outside of the Caribbean. Any children with you will be interested in the petting zoo out back.

If you don't find this an appealing photo subject, stop for one of the freshly made fruit milkshakes; my favorite is the key lime. These shakes make this a favorite stop for cyclists, bikers, and joggers (additional photo subjects). Open 8–7 daily, including holidays, except

Where: The adjacent cities of Homestead and Florida City are located at the southern end of the Florida Turnpike (FL 821) below Miami. Florida City is also the final stop before the Florida Keys.
Noted for: Roadside attractions, vegetable farming, wild animal rehabilitation, birding
Best Time: Winter dry season, when mosquito population is manageable
Exertion: Minimal
Peak Times: December through March
Facilities: At developed sites
Parking: In designated lots and on the sides of the road; beware of soft road shoulders after rains
Sleeps and Eats: Chain motels and restaurants line US 1 in Florida City.

September and October, when it's closed (prime hurricane season). Contact: 305-246-1592 or www.robertishere.com.

Pro Tips: Morning is the best time to shoot the fruit stand's exterior, purple martin houses, and petting zoo. For the shaded fruit displays inside, use a tripod or a dedicated external flash with diffuser. The built-in flash will probably create hot spots in the center of the typically shiny fruits.

Everglades Outpost (2)

Continue on FL 9336 for a short distance to the Everglades Outpost on the left. Admittedly this modest nonprofit rescue facility for abandoned and injured animals doesn't leave a good impression. The caged animals make you wish for wire cutters to pry a wider opening for your camera.

The range of animal subjects is broad; there

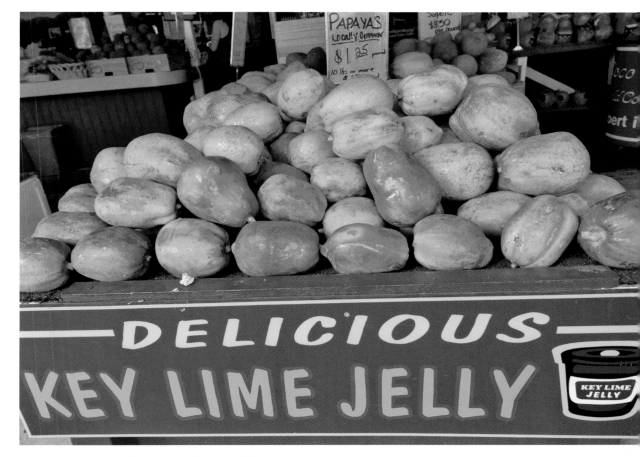

Papaya display at Robert Is Here! fruit stand

are exotic creatures from around the world, most are abandoned pets. Florida residents include the Florida panther, black bears, snakes, and whatever injured animals may have been recently rescued. The volunteer staff, called wranglers, has worked with big name TV shows and is helpful in posing manageable critters for photos. Outside the main tourist season, with the place almost to yourself, the staff may be willing to uncage the docile animals.

Images of alligators and wading birds may be why you came to the Glades, but after visiting Everglades Outpost you could leave with photos of lions and tigers and bears, oh my!

Closed Monday and Wednesday. Open 9:30–5:30 other days. Admission fee. Contact: 305-247-8000 or www.evergladesoutpost.org.

Pro Tips: Have a well-charged strobe since none of the subjects is static. The volunteer staff is usually obliging in providing animal portraits unless you act like a professional photographer. Then, additional charges may apply. Play tourist, which you are. Forget the photo vest.

Everglades Alligator Farm (3)
Proceed south on FL 9336 until it makes a sharp, 90-degree right turn to ENP. Go straight ahead on SW 192nd Avenue for about 2 miles

Florida king snake at Everglades Outpost

to Everglades Alligator Farm. Texas may grow beef and South Dakota bison, but in Florida we grow alligators. Alligator farming began to sustain the population after it was being depleted to make boots, belts, and purses. As the first gator farm in Dade County, Everglades Alligator Farm typically houses about 2,000 alligators along with crocodiles (American and Nile) and snakes. Be here at gator feeding time for the action. Open daily (except Christmas) at 9 AM. Admission fee. Contact: 305-247-2628 or www.everglades.com. Check ahead for animal show times.

Everglades Farmlands (4)

After visiting the alligator farm, drive the 2 miles back to FL 9336 and turn left (west) to-

ward ENP. Almost immediately you'll be in the Everglades Farmlands, where today, as in the 1800s, vegetable farming is the primary occupation. Known as the Redland for the red clay deposited on the area's oolite rock underbase, this region is famous for producing fruits not grown anywhere else in the nation. This also is the only U.S. location able to grow tomatoes in winter.

What you see on a particular day depends on whether the crops are still in the ground or being picked. Nothing may be happening when you pass. My most interesting shots have been the irrigation trucks spraying huge geysers of water over the fields. When the light is right (typically early morning), you can catch a rainbow around the spirals of shooting water.

Aerojet Road (5)

After the farmlands, look for a left turn onto the paved road SW 232nd Avenue. Known locally as Aerojet Road, this isn't always the easiest turnoff to find. If you end up in ENP, only a mile farther east, turn around and try again. It's worth it because Aerojet Road leads to tiny 500-acre Frog Pond Wildlife Management Area and the Southern Glades Wildlife and Environmental Area, where 188 different species of birds have been recorded.

Lucky Hammock (6)

Just 0.3 miles from the start of Aerojet Road is a nationally known birding hotspot, what local birders call Lucky Hammock because they continually have good luck finding unusual birds. The Tropical Audubon chapter of the National Audubon Society has a list of the birds sighted here: www.tropicalaudubon.org/frogpond.html.

The Annex (7)

There's more. From Lucky Hammock continue south on Aerojet Road to the Annex, watching the power lines on the right, a favorite perch for both native and migratory species. Continuing, you will reach the Annex, a brushy area with more perches for many of the birds also listed for Lucky Hammock.

Irrigation trucks spray water over Redland agricultural land.

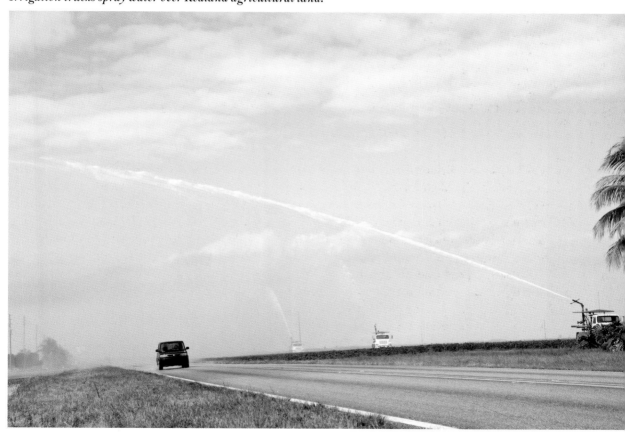

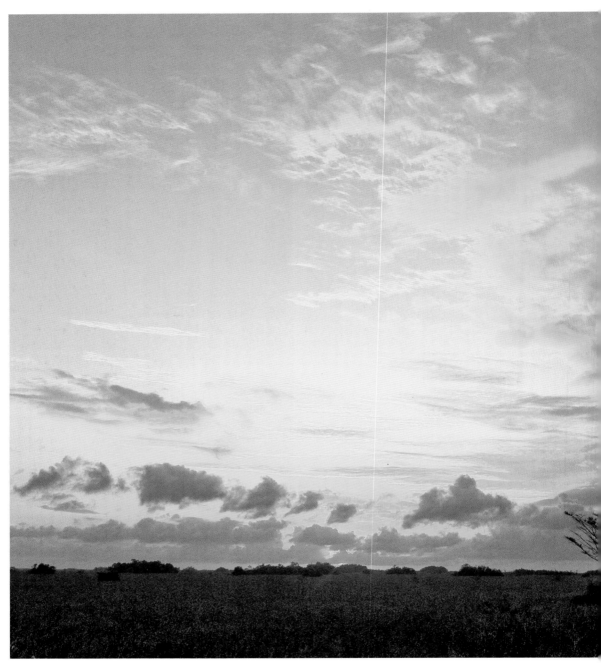

Dwarf cypress trees near Pa-Hay-Okee Overlook

II. Everglades National Park Entrance to Flamingo

Where: Just west of Homestead and Florida City, both located at the southern end of the Florida Turnpike (also FL 821) about 35 miles south of Miami.

Noted for: More than 400 species of birds; 25 mammal species; 60 species of amphibians and reptiles; more than 120 tree species; more than 1,000 species of seed-bearing plants, including 24 orchids; 14 endangered species, including American saltwater crocodiles and Florida panthers

Best Time: Winter dry season, when mosquito population is manageable

Exertion: Minimal

Peak Times: December through March

Facilities: Extremely limited on the 40-mile drive from the entrance gate to Flamingo

Parking: In designated lots and on the sides of the road; beware of soft road shoulders after rains

Sleeps and Eats: Except for the Ernest F. Coe Visitor Center just before the park entrance and the marina at Flamingo 40 miles away, there is no place to buy food or drink. Bring your own. Unless you intend to camp, you'll have to stay in Florida City. The Flamingo Lodge is closed due to storm damage but is expected to be replaced.

General Description: FL 9336 leads to what is called both the "Homestead entrance" and the "east entrance" to Everglades National Park. Because of its proximity to Miami and the Florida Keys, this by far is the most visited of the three ENP sections.

Unlike the other two ENP sections, the Homestead entrance is open 24 hours a day to accommodate the anglers who launch their boats at Flamingo. That offers the flexibility to

photograph anywhere along the road to Flamingo, to try different techniques in every type of setting and every type of lighting condition. The visitor center building, however, is open only during daylight hours, every day including holidays from 8 AM to 5 PM. For current conditions, go to www.nps.gov/ever. Entrance fees: $10 per vehicle, good for 7 days at all park entrances; $5 for cyclists and pedestrians, good for 7 days at all park entrances; $25 annual pass. Free with Golden Age Passport for those 62 and over.

Directions: The entrance is less than a mile west of Aerojet Road (5). From Miami and the Florida Turnpike, follow the turnpike until it ends at Florida City and merges with US 1. Go south on US 1 to the first traffic light. Turn right onto FL 9336 (also called Palm Drive and SW 344th Street). Follow the signs to the park and the Ernest F. Coe Visitor Center. Homestead, FL 33034; 305-242-7700 or www.nps.gov/ever.

Homestead Entrance Sign (8)

Your first photo stop inside the park is the Homestead Entrance Sign. Made from a coral boulder, this is not the typical brown wood or metal national park sign. Morning light is best. If it's overcast, use a strobe for fill light.

Sunrise near main road bridge and concrete drain pipes

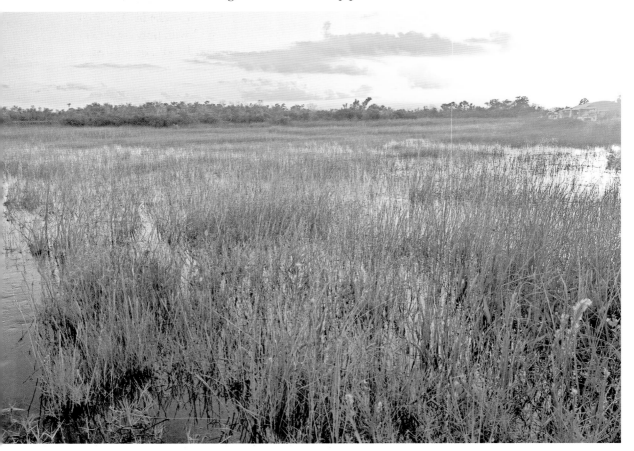

Ernest F. Coe Visitor Center (9)

The Ernest F. Coe Visitor Center not only is the best place to gather general park information, it also has a good selection of in-depth books about ENP. Personally, I've never had much luck finding good photo subjects in the pond behind the visitor center. You may do better. The trees overlooking the parking lot are often filled with birds.

Main Road Bridge & Concrete Drain Pipes (10)

About 1.5 miles beyond the entrance gate you'll cross a small bridge and drive over two concrete drain pipes. These aren't designated as hot wildlife viewing sites, but during low water periods I've occasionally found birds (particularly wood storks) that were scarce elsewhere.

Drive a short distance beyond to the left turn to Royal Palm Plaza, the last major visitor facility until Flamingo. Its parking lot and restrooms are open 24 hours. During daylight, a small bookstore is open, and rangers use it as a base for leading several walks daily from December to roughly the end of April. (Contact the main park number for current programs: 305-242-7700).

Anhinga Trail (11)

Being so close to the entrance, Royal Palm Plaza is the most-visited Homestead location. Animals are so accustomed to people that they seem tame; they're not. They put up with us because Royal Palm is next to Taylor Slough, one of the two major "rivers" carrying fresh water through the park toward Florida Bay and the Gulf of Mexico. Taylor Slough borders the man-made canal paralleling the asphalt pathway at Anhinga Trail. Together, they create excellent conditions for wildlife photography, making this my preferred location, where I can usually count on abundant photo subjects.

I've learned that if the critters aren't interacting here, they're not likely to be active elsewhere. The prime time for photography begins about mid-December, when the water tables start dropping, turning the deep holes in the shallow, grassy plain into holding ponds for fish, which in turn draw the birds and alligators.

The Anhinga Trail's narrow ribbon of asphalt path is actually a remnant of the old highway built in 1916 to connect Homestead with Flamingo. Follow the pavement for a few hundred yards until it ends at an overlook and veers left onto a boardwalk that will loop you over the saw grass prairie. The overlook is a popular place for alligators to sun themselves.

The Anhinga Trail is named for one of the area's most common residents and one of Florida's most distinctive birds. The anhinga, also called water turkey or snake bird, swims almost totally submerged, with only its snaky-looking long neck and head above water. Anhingas are distinctive for how they sit on branches with their wings extended as if they are in a state of alarm. Actually, the anhingas are drying their feathers. They lack the oil glands most other water birds have to keep their plumage dry. If the anhinga doesn't dry itself regularly, the bird could become so waterlogged it would sink.

Other birds normally sighted on the Anhinga Trail are a who's-who of Everglades photo subjects: double-crested cormorants, great blue herons, tricolored herons, great egrets, and snowy egrets. Alligators and turtles are also plentiful. Late in the day gators sometimes crawl up on the asphalt to keep warm. Feel free to take their photo, but give them a wide berth.

Gumbo Limbo Trail (12)

A second nature trail at Royal Palm Plaza is the Gumbo Limbo Trail, a 0.3-mile loop winding and curving through a jungle-like moist forest. The trail is named for the tall tropical gumbo

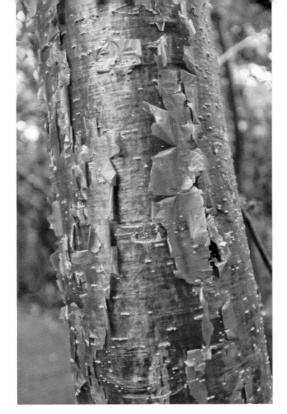

The distinctive peeling red bark of the gumbo limbo tree

limbo trees native to the Caribbean; South Florida is the tree's northern-most range. The tree, known for its distinctive red bark that appears to be peeling, is often called "the tourist tree" because its peeling bark resembles the sunburned skin of first-time South Florida visitors.

The dense foliage here is a reliable place to locate the *Liguus* tree snails that graze on the algae, fungi, and lichen growing on tree bark. Use a detached flash to capture true shell color and detail; pop-up flashes may create a hot spot on the snail shell, whose predominant color is often white.

Return to the Main Park Road and turn left (south). You'll move from open saw grass plain to the higher, dryer ground of the Pinelands. This sizable pine forest gradually evolves into

a hardwood oak hammock if it is not periodically burned. The park service does use controlled burns periodically to eliminate young hardwoods, which leaves the unharmed pine trees with a sooty base, a decidedly unphotogenic condition.

Long Pine Key Campground (13)

Six miles from the main entrance follow the sign to turn left off the Main Park Road to the 108-site Long Pine Key Campground. The lake here tends to attract limited wildlife that is most active just before and after dawn but is sparse during the day. The campground, however, is the hub for more than 28 miles of interconnecting trails through the pine forest, making this is a good base camp for penetrating into parts of the Everglades few ever see. Campsites are on a first-come, first-served basis: www.nps.gov/ever/planyourvisit/longpinecamp.htm.

Pinelands Trail (14)

A 0.4-mile loop trail provides a quick look into the pines on the Main Park Road 7 miles from the entrance center at the Pinelands Trail, on the right. Slash pines, also called Caribbean or Dade County pines, are the only pine species that can grow in the demanding environment of the Everglades. Slash pines are tough, able to take root in the tiny cracks and potholes that pock the limestone ground where the soil layer is thin.

This uneven terrain, known as a karst landscape, was formed by the frequent, hard rain that dissolves the porous limestone rock. Leave the marked trail and, without special attention to where you're walking, the limestone hollows become ankle twisters.

Rock Reef Pass (15)

Back on the Main Park Road, your next marker is Rock Reef Pass, whose elevation is a mighty 3 feet above sea level. If you live around mountains you may find the terrain laughably low,

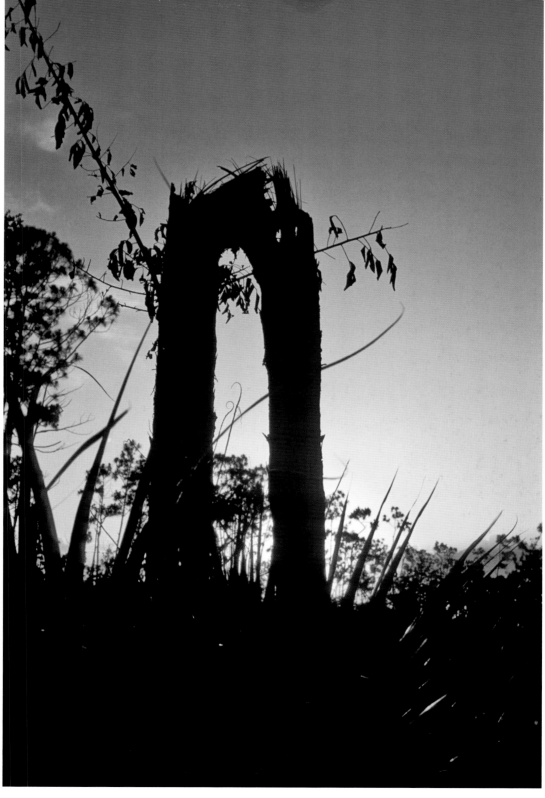

The Pinelands Trail at sunset: The tree was snapped into a U shape by hurricane-force winds.

but in the Glades it's considered notably high. A short boardwalk here on the right leads into a forest of dwarf cypress, trees stunted by the lack of nutrients in the shallow soil.

Dwarf Cypress (16)

A few miles beyond Rock Reef Pass, turn right at the sign pointing to the Pa-Hay-Okee Overlook. Although the right side of the road contains mostly open prairie, in several sections are good examples of dwarf cypress. The tiny trees, mostly pond cypress, grow in some of the toughest conditions in the Glades. However, quite a few of the scrawny trees are close to the road, making this a good place to take advantage of their bleached out appearance. They also look quite dead after their nee-

dles drop in the fall. Put on some wading boots to approach the trees with a variety of wide-angle lenses, including a fisheye, for some dramatic landscape photography. Just as bleached steer skulls are a symbol of the American West, these gnarled trees are emblematic of ENP.

Pa-Hay-Okee Overlook (17)

Thirteen miles from the entrance gate is Pa-Hay-Okee Overlook, an elevated platform and 0.25-mile boardwalk. The observation platform offers an excellent glimpse of the enormous Everglades saw grass prairie. As far as you can see, there is only a grassy field-filled river punctuated occasionally by scattered, island-like palm hammocks. It's hard to imagine anyone ever could survive such hostile condi-

The boardwalk at Rock Reef Pass

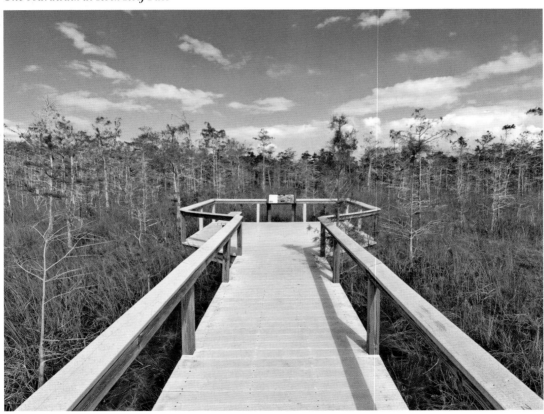

tions, yet the Seminoles did. Because of the dramatically different directions of the sunlight, this is another place worth photographing both morning and afternoon. In terms of critters, birds are your most likely subjects: red-shouldered hawks, red-winged blackbirds, and that most essential scavenger, the American black vulture.

Swamp Walk (18)

After leaving the Pa-Hay-Okee Overlook, rejoin the Main Park Road and turn right toward Flamingo. In about a mile on the left you'll see a small pull-off and what looks like a game trail leading off through the grass. This spot is where park rangers often lead visitors on a Swamp Walk into a nearby cypress dome with air plants and barred owls. The water here can be as much as waist deep, but for swamp walks water below knee level is a lot more comfortable. It's safer to join a guided walk instead of wandering off on your own due to the possible presence of cottonmouth moccasins and an alligator that resides here. If you're wearing an old pair of tennis shoes tightly tied on, this is a fun experience. You'll need a walking stick to help keep your balance in the mucky areas.

Mahogany Hammock Boardwalk (19)

At 20 miles, the half-mile Mahogany Hammock boardwalk leads to the nation's largest mahogany tree, boasting a 12-foot girth and topping out at 90 feet. A so-called champion tree because of its huge size, it is a disappointing photo subject because of the thick foliage around it and because you're not able to move back far enough to capture the entire tree. Even a fisheye lens doesn't work. Still, look for birds early and late, particularly redheaded woodpeckers.

Also worth your attention are the huge strangler figs engulfing many trees beside the boardwalk. The strangler fig, which looks like

A popular trail for swamp walks into the saw grass.

a thick vine, is a fast-growing parasitic tree that sprouts from the bark of the host tree and then drops air roots to establish its own underground root system. In the process, the trunk of the strangler fig often encases and smothers its host.

Pro Tips: Due to the thick tree canopy, rely on a strobe and wide-angle lens for sharp details

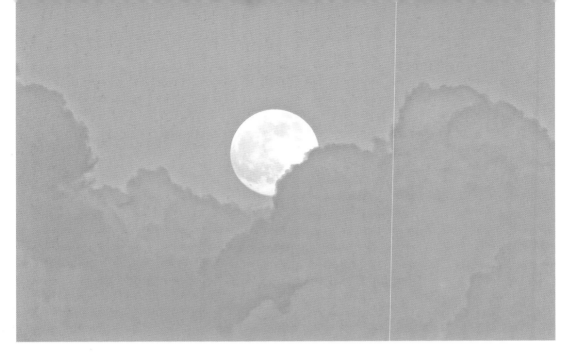

Clouds partially block a full moon at the Mahogany Hammock parking lot. The shot was taken with a 400mm lens braced against a car window.

of this botanical struggle. Take time to bracket to see how little flash is needed. It's hard to get detail on the grayish bark.

Paurotis Pond (20)

Between Mahogany Hammock and Nine Mile Pond on the Main Park Road is Paurotis Pond, a fairly small body of water known for its concentrations of nesting birds in spring and summer. The trees bordering the pond become a rich rookery for hundreds—if not thousands—of birds. When the birds are present, kayaking and canoeing are not permitted.

Pro Tips: Use a long telephoto lens and tripod for acceptable photos. Vary your metering since many of the birds nesting here are white egrets against a darker green background. Center-weighted metering may be best if the white birds are badly overexposed. You may be fortunate enough to find pink roseate spoonbills, but their rich colors also fade in bright

sun. (In winter, you can usually find a black vulture perched on the sign warning not to approach beyond that point in summer).

Nine Mile Pond (21)

Unless you plan to canoe or kayak, the popular but demanding 5-mile trail at Nine Mile Pond will probably not be of much interest. It's located 28.5 miles from the park entrance on the Main Park Road on the left. Animal life near the parking lot is sparse except for the black vultures that guard the shoreline, sometimes accompanied by alligators. However, late in the afternoon, I find the pond makes a good scenic landscape, as it's one of the few picturesque open water locations in the Homestead ENP section.

West Lake (22)

West Lake, 30.5 miles from the park entrance on the Main Park Road, on the left, is another celebrated canoe/kayak trail. For photogra-

phers, the 0.5-mile boardwalk through a mangrove forest is usually more productive. For the first time you can document the four types of salt-tolerant trees that form the intricate web of roots that help stabilize the shoreline. This is also your first opportunity to photograph an American saltwater crocodile. If you don't find one, don't worry. They're almost a sure thing behind the Flamingo Marina (29).

Mangroves are a vital part of Florida's ecosystem. On the coast, they help buffer the shoreline against the pounding waves of hurricanes and tropical storms. Everywhere the trees grow, their intricate root systems make wonderful hiding places for shrimp, crabs, lobsters, and small fish. Mosquitoes and mangroves go hand in hand, so use repellent. Look for bromeliads (air plants) growing in the mangrove branches. It's unusual for them to be at such low heights, but dry habitat is scare here.

Pro Tips: Midday, when the sunlight is intense elsewhere, is often the best time for a mangrove forest walk. Not only is it cooler inside the towering mangrove canopy, the overhead light illuminates areas otherwise in the shade. Mosquitoes are also less of a problem at midday. Two cameras would be ideal here: wide-angle for close-up details and short telephoto (200 mm) with external flash for wildlife. If it's overcast, take your tripod, too. It can be amazingly dark on a cloudy day inside mangroves as thick as these.

Mrazek Pond (23)

When the water conditions are right, Mrazek Pond, near Flamingo on the Main Park Road, will be almost blocked off by a pack of photographers standing shoulder to shoulder, all using cameras mounted on tripods. The sight always reminds me of the press corps gathered for important space launches at Kennedy Space Center a few hundred miles up the coast.

The photographic conclave at Mrazek Pond

is often used to symbolize the excellent wading bird photo ops, but it is misleading. Much of the time the pond is home to only a few visible birds. Yet once a year, typically for two weeks toward the end of March or in early April, Mrazek Pond can be one of the hottest birding locations in America. Hundreds of birds representing numerous species are present throughout the entire day, gorging on the readily available food in shallow flats that replace the pond. Each year the Homestead visitor center fields hundreds of calls from photographers asking if "the gathering" is happening yet.

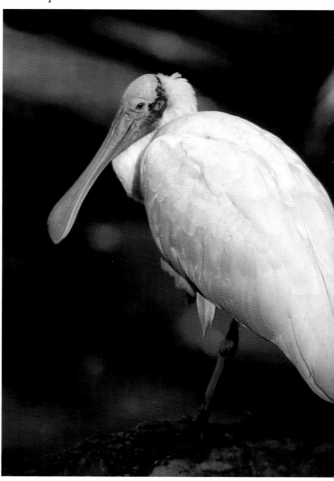

Roseate spoonbill

Pro Tips: In the morning, birds tend to gather in greater numbers. They are also backlit then. Watch for action—an egret flapping its wings—to make the bird stand out. Avoid having another bird in the background as a distraction. In the afternoon, there may be fewer birds, but the light is on them. At either time, bracket to see what setting captures the best detail. Use a

The mangrove forest at West Lake through a yellow filter

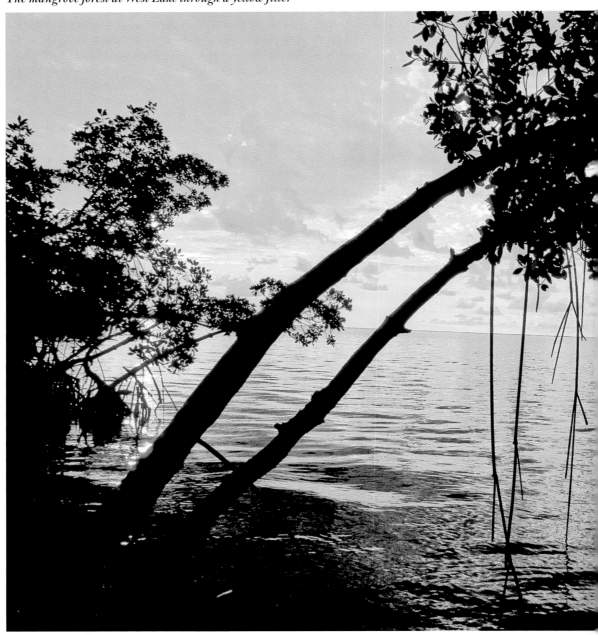

tripod with your shutter speed set for at least 1/500 to capture the motion without blurring. A faster shutter speed would be even better, using noise-removal software where needed.

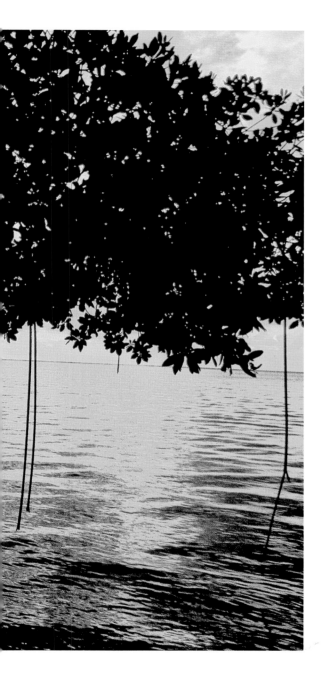

Hiking Opportunities: Between Mrazek Pond and Flamingo, now only 7 miles south, are four of the longest trails in the Homestead section. All are well worth walking, but I suggest ignoring them unless you're going to be in the area for some time or you want a chance to see pink flamingos outside of a zoo, an exceptional sight. Flamingos, once so common in the 1800s, gave the old fishing town of Flamingo its name; they became rare for much of the 20th century, devastated by plume hunters.

If flamingos had almost become extinct in Florida, how are they returning? The birds apparently never did breed in Florida, though a large population would visit from the Bahamas and the Caribbean outside of mating season. In recent years, a limited number have returned periodically, but a hike of several miles to their location is no guarantee they'll be on hand. So before making a wasted hike, check at the Flamingo Visitor Center, where the latest wildlife sightings are posted.

Snake Bight Trail (24) and Rowdy Bend Trail (25)

The walks leading to flamingos are on Snake Bight Trail and Rowdy Bend Trail. The shorter (1.6 miles each way) Snake Bight Trail ends at a boardwalk overlooking a bight (small bay) where the flamingos hopefully will be present near high tide. The longer (2.6 miles each way) Rowdy Bend Trail offers the advantage of sighting woodland birds before it joins the Snake Bight Trail to end at the same boardwalk.

Christian Point Trail (26)

Another coastal hike is the 1.8-mile (each way) Christian Point Trail leading to a different section of Snake Bight Bay. The walk goes through a forest of buttonwood and mangrove trees filled with air plants (bromeliads) and mosquitoes; repellent is essential. Plan to arrive at Snake Bight Bay near high tide for the best birding.

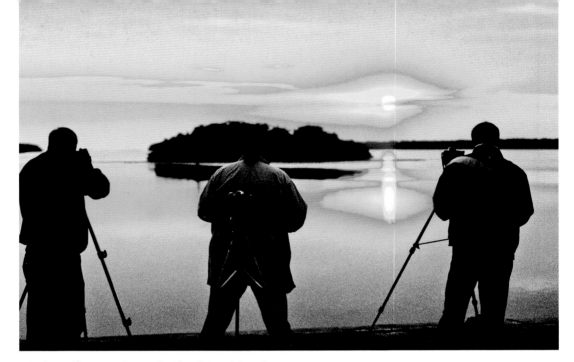

Photographing sunrise at the Flamingo Visitor Center

Bear Lake Trail Canal (27)

Taking you away from the coastline is Bear Lake Trail Canal, on the right just a half-mile before the Flamingo Visitor Center. If the Bear Lake access road is closed, you'll have to trudge 1.8 miles along the road to the official trailhead, where the 3.5-mile walk (roundtrip) parallels the old 1922 Homestead Canal, going through a hardwood hammock and mangroves, ending at Bear Lake, where, if you're lucky, the trees will be filled with egrets.

Flamingo Visitor Center (28)

After 40 miles you've finally arrived in Flamingo, situated on Florida Bay. Here, fresh and saltwater mix to produce wildlife viewing opportunities not easily found elsewhere in the park. Drive past the marina and boat ramps on the left to the Flamingo Visitor Center, sturdily built on concrete pylons many feet above ground. This is a modest facility with seasonal staffing, but the wildlife sightings posted here are invaluable. A notice here a few years ago alerted me to the presence of American saltwater crocodiles behind the Flamingo marina. They had been hunted almost to extinction; only 200 to 300 were left in 1976. I never expected to photograph a saltwater croc in the wild; they ranked with Florida panthers for their scarcity. Thankfully, not anymore.

Flamingo Marina (29)

You can usually photograph the growing gathering of crocs behind the Flamingo Marina most days around noon, when the animals are sunning themselves. A small bridge to the right of the rental kayaks puts you surprisingly close to their hangout on the opposite bank. Unfortunately, the bridge often shadows the reptiles with what look like bizarre dark tattoos.

Pro Tip: Light clouds eliminate the bridge shadows on the crocs and sometimes a powerful flash will, too.

Since alligators also cruise this area, it helps

Canoes at Flamingo Marina

to know how the two reptiles differ. The easiest way to tell is by the shape of their head. Compare the two in our Wildlife Photo Gallery on page 27.

Whitewater Bay (30)

To attain more than just the usual land-bound perspective of the Glades, rent a canoe at the Flamingo Marina to venture out on your own into the wilderness. Plenty of good maps are available there and at www.nps.gov/ever/plan yourvisit/maps.htm. For a better overview, join the daily National Park Service motorized Flamingo boat tour that goes inland to the calmer waters of Whitewater Bay, one of Florida's largest and most remote bodies of water. Landscape photos predominate, though birds and animals often appear. In peak season, make reservations while at the Coe Visitor Center or call ahead: 239-695-3101.

Eco Pond (31)

A mile south of the Flamingo Visitor Center on the Main Park Road is Eco Pond, on the right. Park on the road shoulder; there is no paved parking area yet. Eco Pond, once famous for its large bird rookery, is a sad remnant of itself. The double punch of 2005's Hurricanes Katrina and Wilma tore down not only the trees used for nesting but the observation platform that once provided a magnificent view of hundreds of nesting birds. Eco Pond is slowly recovering. Wading birds, song birds, and ducks along with alligators and soft-shell turtles are all becoming more visible. It was here I photographed a "high-walking" alligator at twilight strolling beside the Main Park Road to Flamingo Campground (see page 15).

Flamingo Campground (32)

The Main Park Road dead-ends at the Flamingo Campground situated on Florida Bay, which was also the gator's destination. Have your camera ready for wading birds at the far left end of the parking lot. Another option, the Guy Bradley Trail linking the visitor center and campground, has been closed for several years due to storm damage. No telling when it may reopen.

Bayshore Loop Trail (33)

To see more of Florida Bay, always a good sunset location, walk the 2-mile Bayshore Loop Trail; the trail starts in the campground at the back of Loop C. Along the way you'll witness more devastating hurricane effects and also see the ruins of an old fishing village, all good subjects in low light. And hopefully you'll be able to photograph wading birds feeding at low tide.

A wide-angle view of saw grass prairie surrounding Pa-Hay-Okee Overlook

III. Homestead to Tamiami Trail

Where: From Florida City to the Tamiami Trail (US 41)

Noted for: Art deco architecture, tree farms, exotic fruits and flowers, famous "castle" made of coral blocks

Best Time: Winter dry season, when heat and humidity are at their lowest

Exertion: Minimal

Peak Times: December through March

Facilities: Readily available though sparser as you near the Tamiami Trail; leave Homestead with a full gas tank

Parking: In designated lots and on the sides of the road; beware of soft road shoulders after rains

Sleeps and Eats: Readily available until you reach the Tamiami Trail

Sites Include: Roadside attractions, small section of ENP, exotic fruit and flower growers

General Description: The various sites roughly parallel Krome Avenue (also FL 8336) going north to the Tamiami Trail from Florida City.

Directions: Start from Krome Avenue in downtown Homestead; a GPS unit will show the fastest routes to some attractions.

One of the region's oldest cities, Homestead's heyday began when Henry Flagler decided in 1904 to extend the railroad to Key West from Miami. This allowed Homestead growers to ship their produce north by rail easily for the first time. As the city grew, its wealthier citizens built homes in the trendiest styles of the day, a mix of Mediterranean revival and brightly colored art deco with its sometimes futuristic designs.

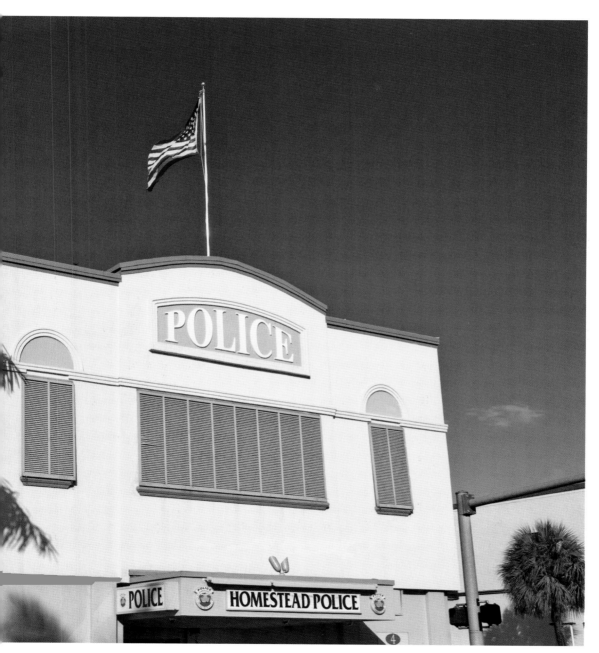

An art deco building in downtown Homestead shot with a medium telephoto lens

Historic Downtown Homestead (34)

Historic Downtown Homestead covers an eight-block district with many renovated antique shops, art galleries, and restored 19th-century buildings. Most are easily visible driving along Krome Avenue, the main street through Homestead. The most famous is the Historic Homestead Town Hall Museum at 41 North Krome Avenue; 305-242-4463. Built

Wide-angle lens close-up of a bloom at
R. F. Orchids

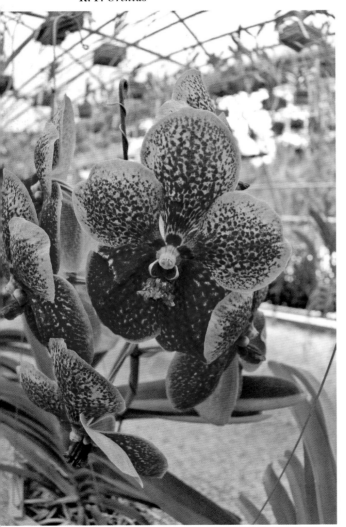

in 1917, its displays trace the city's history from 1912 to the present. Open 1–5 Tuesday–Saturday. Free.

Homestead's population boom was cut short by a devastating 1926 hurricane that caused many people to move away. (History repeated itself in 1992 when Hurricane Andrew, one of the most destructive hurricanes of all time, practically destroyed Homestead.)

After 1926, it took many years before flower power allowed Homestead to regain its equilibrium. Not just any flowers, but beautiful orchids that appear to have the power to drive some people crazy (it's called orchid madness). In Florida, orchid collectors caused so much destruction that taking plants from the wild is banned and all of the state's native orchids are now classified "endangered."

R. F. Orchids (35)

Although Everglades National Park has documented 35 different orchid species of its own, the chance of seeing one flowering is poor except in summer. With luck, you may find one blooming at Homestead's R. F. Orchids, a world-class facility with over 800 American Orchid Society awards, more honors than any other nursery or individual grower in the nation. R. F. Orchids, which displays flowers from around the world in addition to its own award-winning hybrids, offers guided tours on Saturdays and Sundays at 11 and 3. Drop-ins are welcome anytime. R. F. Orchids, 28100 SW 182 Ave., Homestead FL 33030; 305-245-4570.

Directions: From the Florida Turnpike take Exit 5 (SW 288 Street) and go right (west) on SW 288 Street for about 4 miles to SW 182 Avenue (Robert's Road). Turn right on SW 182 Avenue R.F. Orchids is on the left, 0.4 mile. Open 9–5 Tuesday to Sunday, closed Monday; www.rforchids.com. Free.

Pro Tips: The plants are under a thick plastic roof, a kind of semi-shade requiring a flash for brilliant colors. Use a tripod for extreme close-ups. The rows of flowering orchids are probably the most colorful sight you'll see anywhere in the Glades, in Florida, for that matter.

Fruit & Spice Park (36)

Both strange and familiar spices and fruits grow on the vine at the 37-acre Fruit & Spice Park, the only tropical botanical garden of its kind in the country. Operated by the Metro-Dade County Park and Recreation Department, the Fruit & Spice Park cultivates more than 500 varieties of rare fruits, herbs, spices, and nuts from around the world, including 80 varieties of bananas and 70 varieties of bamboo. Who knew there were so many varieties of bananas?

Although a tram tours the site at 11, 1:30, or 3, I prefer to follow the map available at the entrance to photograph at my own pace the two dozen sites showcasing local and international plants and trees.

Directions: 24801 SW 187 Ave.; 305-247-5727. Admission fee. Open 10–5 daily except Christmas Day; http://miamifruitandspicepark.com.

Pro Tips: You'd have to travel around the world to document so many varieties. Use a strobe to illuminate the fruits and nuts covered by leaves. Photo subjects vary by season.

Homestead Foliage Fields (37)

Traveling north on Krome Avenue, the Homestead Foliage Fields begin soon after leaving downtown. You'll pass field after field of vegetable, fruit, and ornamental tree farms that create America's tropical breadbasket. The groves, fields, and tree farms produce almost $1 billion of tropical foliage, vegetables, and fruits annually with more than 83,000 acres

Advertising Homestead's agricultural products

and 1,600 farms and nurseries providing landscaping materials to both the Southeast U.S. and the Caribbean. This is one time I'm not singling out any specific locations because the photo opportunities change both hourly and seasonally. You should have no problem finding many sites of your own.

Pro Tips: Go north early to capture backlit fields being watered or soft-lit seasonal displays for Halloween and Christmas. In photographing a cluster of plants, try different perspectives: For low-lying plants, get down on their level. At a tree farm with acres of palms,

Flash brings out details of an air plant at the Chekika Unit of Everglades National Park

get underneath the branches and shoot skyward with a wide-angle or fisheye lens. The effects can be dramatic.

Chekika Unit, ENP (38)

Continuing north on Krome Avenue, at the intersection of Krome with Kendall Drive (SW 88 Street) turn left toward the Chekika Unit of ENP. Stay on Kendall for about 6 miles until it ends at SW 168th Street. Turn right on SW 168th and go 0.6 miles to 237th Avenue and the entrance road to Chekika, on the left. Often open only in winter due to high water conditions, Chekika sits on an island of hardwoods a few feet above the wet open saw grass prairie surrounding it. Larger animals found here include alligators, birds, and bobcats. No fee; open seasonally 8–5. Although usually quiet during the week, Chekika's late opening and early closing place it outside the normal prime wildlife viewing times.

Coral Castle (39)

Florida is known for attracting unusual people, and one of the most peculiar was Latvian immigrant Edward Leedskalnin, who single-handedly built the famous Coral Castle. This National Historic Site, furnished with such oddities as a 5,000-pound stone rocking chair and a 5,000-pound heart-shaped Feast of Love table, is a popular subject of TV shows and books dealing with the paranormal.

Not surprising since Coral Castle is made of 1,100-tons of coral blocks sprawling over 10 acres, done apparently by Leedskalnin alone and without the use of any machinery. Most remarkable, after taking 16 years to assemble the structure, Leedskalnin packed it up and moved it 10 miles farther north from Florida City to Homestead using only a borrowed truck. How did Leedskalnin do it? No one knows. The reclusive Leedskalnin always worked at night so witnesses would not discover the secrets that died with him in 1951.

Directions: From Homestead take SW 288 Street, turn left onto SW 157th Avenue. Coral Castle is located at 28655 South Dixie Highway, Homestead, FL 33033; 305-248-6345. Hours: Sunday–Thursday 8-6, Friday & Saturday 8-9. Admission fee; www.coralcastle .com/index.php.

Notable Options: The following don't readily match our other Everglades subjects but may still be of interest. Specific directions are at their websites. The Homestead Sports Complex hosts all levels of baseball play from Major League to Little League games; www .cityofhomestead.com/pages/recreation/park-facilities.aspx. The 65,000-seat Homestead Miami Speedway hosts several world-class motorsports including IndyCar and NASCAR; www.homesteadmiamispeedway.com. Biscayne National Park is the largest marine park in the National Park System, but 95 percent of its 173,000 acres are covered by water; www.nps .gov/bisc/index.htm.

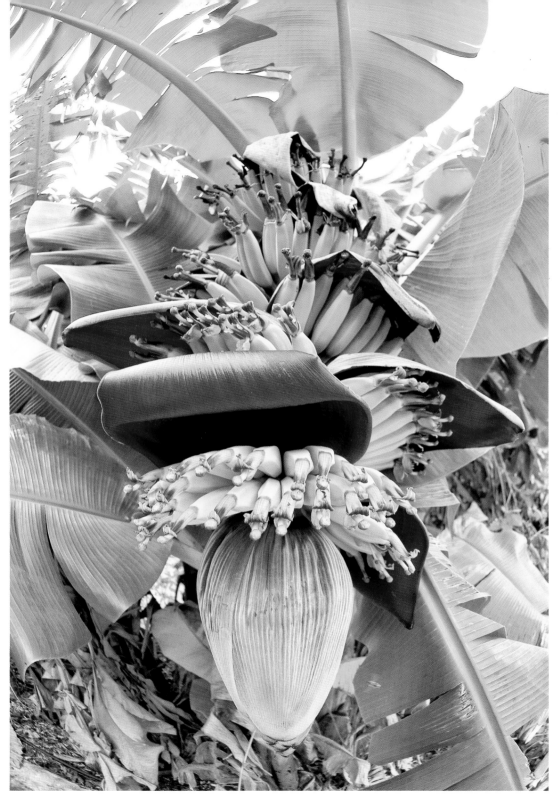

A giant banana flower at the Fruit & Spice Park

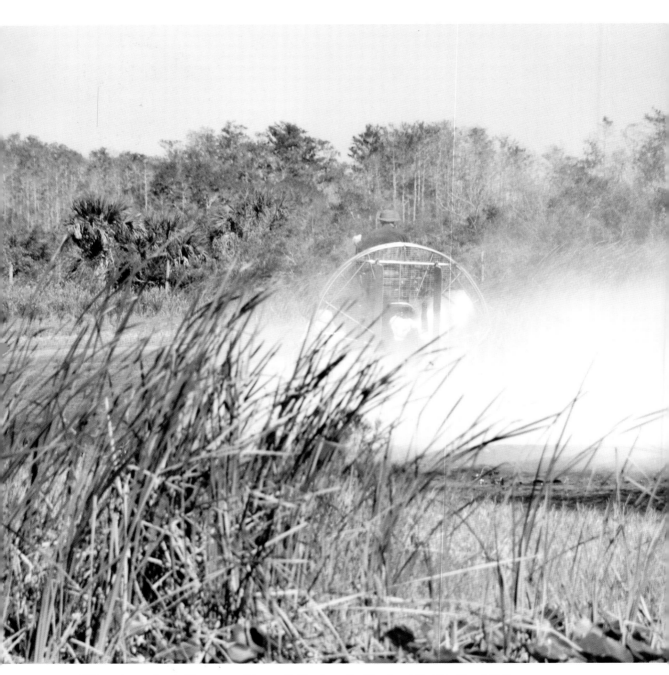

Miccosukee airboat rides are readily available along the Tamiami Trail to Shark Valley.

IV. Imitation Jaws: Shark Valley, Everglades National Park

Where: Along US 41 (Tamiami Trail) going west for 17.7 miles from the Krome Avenue/Tamiami Trail junction to the Shark Valley entrance of Everglades National Park.

Noted for: Tamiami Trail for saw grass prairies and airboat rides, Shark Valley for saw grass prairies, diverse wildlife, cycling, tram road, and observation tower

Best Time: Winter dry season, when heat and humidity are at their lowest

Exertion: Minimal unless you cycle the paved 15-mile-loop tram road

Peak Times: December through March

Facilities: Restaurants and fuel are readily available nearby.

Parking: There is parking in designated lots. The US 41 road shoulder may be too narrow to pull off safely. Large trucks and big RVs are common. At Shark Valley, use the single designated parking area, open daily from 8:30 to 6. Cars are not allowed on the tram road.

Sleeps and Eats: RV camping is nearby but the closest motels are in the direction of Miami/Homestead or Everglades City. There is a Miccosukee restaurant across from Shark Valley.

General Description: You'll find roadside attractions and airboat rides on U.S. 41 leading to Shark Valley, located at the northern border of Everglades National Park, just east of the Big Cypress National Preserve. Compared to Homestead, accessibility at Shark Valley is far more limited. The single main road, a 15-mile paved loop, is off-limits to cars. You can travel the road via guided tram tour, by bicycle, or on foot; rental bikes are available. The midpoint of the loop road arrives at Shark Valley's most

Sunset from the Visitor Center Canal Overlook

tion, cost $8 million, and employed thousands of workers who blasted away thousands of tons of limestone rock. When the Trail was completed in 1928, the first auto accident occurred within just two hours of its opening. A motorist fell asleep on the ruler-straight road, hitting a cypress tree, thus establishing the accident-filled pattern that continues today.

Airboat rides (40)

Roadside attractions used to be a mainstay along the Tamiami Trail. Many have vanished, but almost a half dozen airboat rides still operate between Krome Avenue and Shark Valley. The stops include Coopertown Airboats, Gator Park, Everglades Safari Park, Buffalo Tiger's Everglades Airboat Ride, Sunset Island Small Airboats and Gift Shop, Tigertail's Airboat Rides, and the Miccosukee Cultural Center, which also offers airboat rides.

At Shark Valley, don't expect to see sharks in any way, shape, or form, including fossilized prehistoric teeth. The term comes from two natural features. First is Shark River Slough, the area's huge saw grass prairie that carries the most concentrated surface water flow in the Everglades. The slough is funnel-shaped, narrowing from some 20 miles wide to the north to about 6 miles near the coast. The surface water advances slowly through Shark River, eventually flowing into the Gulf of Mexico.

By Everglades standards, Shark River Slough runs through a valley: 10 miles to the east or west the land elevation is a whole 1 foot higher. Hence Shark Valley, a much catchier title than Shark River Slough Valley.

Shark Valley is open daily from 8:30 to 6. The parking lot is closed outside of those hours. The Shark Valley visitor center has limited facilities, including educational displays, books, and souvenirs. Entrance fee: $10 per vehicle and $5 for cyclists and pedestrians, good for 7 days at all park entrances; $25

famous man-made feature, a 65-foot-high observation tower.

From the junction of Krome Avenue and the Tamiami Trail, go left (west) for 17.7 miles to the Shark Valley entrance. US 41, which crosses the Everglades to link Miami and Naples, is better known as the Tamiami Trail. One of Florida's most scenic drives, the road's name is not based on an Indian term but is a contraction of two Florida cities, Tampa and Miami, which US 41 was built to connect.

The cross-Glades section from Naples to Miami required over a dozen years of construc-

annual pass. Entrance free for those 62 and above with Golden Age Passport. Contact: 305-221-8776 or www.nps.gov/ever/planyourvisit/svdirections.htm.

The paved loop road dominating the landscape is referred to as two separate parts, the east and west sections. The straight West Road, built for oil exploration before this was a park, parallels a flowing canal situated only feet from the pavement. The canal's large gator population has lost all fear of humans. Keep any young children close at hand. The reptiles, both large and small, laze everywhere around the road, not always readily obvious.

Visitor Center Canal Overlook (41)

The Visitor Center Canal Overlook is a small wooden observation platform beside the canal where gators, otters, and wading birds are common. During winter's early sunset when the park is still open, set up a tripod here or anywhere on the West Road to photograph birds roosting in trees across the canal. The sun will set behind them.

Bobcat Boardwalk (42)

Two short walks start from the visitor center. The Bobcat Boardwalk crosses the median of wilderness separating the East and West Roads. The trail starts from the paved road, only 100 yards south of the visitor center. The boardwalk, about 500 yards long, penetrates a saw grass prairie with extensive cattails before entering a lowland hammock of willows and other trees. Interpretive signs identify various plants and ecosystems and, yes, you definitely could see a bobcat lurking in this area. With low sunlight, this is a nice walk after the last tram of the day. Large grasshoppers like the top of the boardwalk railing.

Otter Cave Hammock Trail (43)

The loop Otter Cave Hammock Trail starts about a half-mile south of the visitor center,

entrance from the West Road only. It passes through a hardwood hammock for about 200 yards. The trail, a combination of rough limestone and small footbridges for crossing a stream, goes past such well-known Glades trees as the peeling red-barked gumbo limbo and the gnarly strangler fig (a huge strangler is marked by a sign). The trail returns you to your entrance point. Pay close attention to your return direction. Go right for the visitor center. Go left and the next man-made structure is the observation tower about 7 miles distant.

Tram Road (44)

How best to photograph Shark Valley? Since the 15-mile loop Tram Road lacks crossover trails (except Bobcat Boardwalk) and any kind of shortcut, most visitors take the tram ride, a two-hour tour with an extended stop at the observation tower. While there will be plenty of photo opportunities from the open-air bus, the ride can be frustrating. The tram is on a set schedule with no time to linger. Worse is the

Everglades bobcat

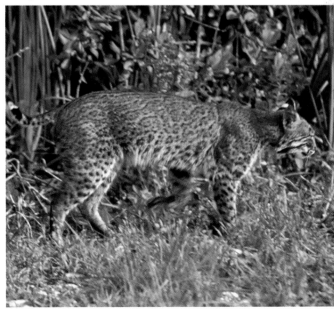

The Shark Valley Tram Road shot from the top of the observation tower

After the observation tower you return on the more zigzag East Road that features four "borrow pits" (quarries) used to build this road section. These deepwater pits act like African water holes during the dry season, attracting animals and birds from most nearby areas. To cycle, bring your own bike or use a rental from the tram ride concessionaire: 305-221-8455 or www.sharkvalleytramtours.com. State law requires those 16 years and under to wear a helmet (also available for rent). Unfortunately, bicycle rentals don't start until 8:30 AM and must be returned by 4 PM, two hours before the park closes. You lose out on the best light at both ends of the day since the park doesn't open until 8:30 AM.

Observation Tower (45)

Regardless of transportation mode, everyone's objective is the observation tower with its ramp spiraling up 65 feet to a platform where, on a clear day, you can see for about 20 miles. The view is terrific; it's a good place to stitch together a 360-degree panorama. You may need to be the last to leave the observation tower to accomplish that.

Beneath the tower are restrooms, a water fountain, and an unpaved trail that parallels a pond where big alligators often congregate. If they have, turn around.

Pro Tips: Operating hours for the tram tours change seasonally; park hours sometimes do, too. If you're going to cycle, start as soon as you can, hopefully before the first tram leaves. The best tram ride may be the last one if it returns close to sunset. Go equipped with cameras and lenses for wide-angle landscapes and animal portraits. If you have a polarizing filter, see what it does for saturating colors for views from the observation tower top. Cycling with a tripod is probably more trouble than it's worth, and it's impossible to use one on the tram. Leave it in the car.

view of animals next to the Tram Road. The tram moves slowly ahead to give everyone a good view but if you're at the back the animal may disappear before your turn.

With a backpack suited for carrying camera equipment, I find cycling the Tram Road a much better option. Your quiet approach should provide many more photo subjects, close-up. The circuit takes 3 to 4 hours depending on your pace, and cyclists must travel opposite the tram's route, which means starting on the straight West Road with the canal bordering it.

V. Shark Valley to Big Cypress National Park Visitor Center

General Description: This is the heart of the territory of the Miccosukee Indians, a tribe that didn't exist until the 1950s, when a small group of Seminole Indians split off to form the Miccosukee Tribe of Indians of Florida, a sovereign tribe recognized by both Florida and the federal government. To an outsider, the two Indian tribes appear similar because their traditional costumes are essentially the same and employ the same bright colors. Language is one major distinction between the two tribes. The Miccosukees also follow a more traditional path.

US 41 soon enters the 729,000-acre Big Cypress National Preserve section of the Everglades. Because it's a preserve, many activities are permitted—oil drilling, four-wheel offroading, and even hunting—that are outlawed in a national park. Big Cypress takes its name from the sizable swamp it protects, some 2,400 square miles of subtropical wilderness. About a third of the preserve is covered in mostly pond cypress with only a few remaining old-growth bald cypress as much as 700 years old. The cypresses were cut down for shipbuilding, furniture, clocks, coffins, and stadium seats.

Directions: From the Shark Valley entrance of Everglades National Park, continue west on the Tamiami Trail into the Big Cypress National Preserve.

Miccosukee Indian Village (46)

Why consider a staged setting like the Miccosukee Indian Village, less than a half-mile beyond Shark Valley? Census figures say only 600 members of the reclusive Miccosukee tribe live in the Glades, so an opportunity to photograph tribal members and any aspect of their culture can only be a good thing. This roadside attraction is among the few photo situations

Where: On US 41 between Shark Valley and the Big Cypress National Preserve Visitor Center

Noted for: Miccosukee Indian village, large bald cypress trees, saw grass prairies, *Liguus* tree snails, more airboat rides, and the usual cast of Everglades critters

Best Time: Winter dry season, when heat and humidity are at their lowest

Exertion: Minimal

Peak Times: December through March

Facilities: Extremely limited until Everglades City area

Parking: Designated parking lots and on roadsides if there is enough room and ground is not mushy

Sleeps and Eats: Everglades City has the closest motels. There is almost nowhere to eat until Ochopee after leaving Shark Valley.

the Miccosukees offer. Enter without great expectations or harsh prejudices and you may be pleasantly surprised. I certainly have been.

You have to pass through a gift shop to reach the mock Miccosukee village. Your instinct may be to ignore it. Do so and you could lose your only chance to photograph samples of Miccosukee culture—even those sold as souvenirs. Men's patchwork shirts and jackets, women's blouses, and children's clothes all make colorful subjects. This is the kind of detail you want (strobe required) but won't find in many other places.

The village consists of several shaded stands where at least one and hopefully more Miccosukees will be demonstrating such crafts as intricate patchwork sewing, doll making, basket weaving, and woodworking. These artisans do expect to be photographed, but treat them like people, not photo props; spend time

with them and they may be happy do special setups for you. The Miccosukee Indian Museum also has many worthwhile subjects, many historical. Most are poorly lit and behind glass, so use a flash while standing at an angle (see *Pro Tips* below).

Of course the alligator pit is the main attraction. The pit is an island in good sunlight surrounded by a moat and fence. Alligator wrestling hasn't been highlighted yet in this book because the wrestlers at most roadside attractions are usually Caucasians. Here the wrestler is a Miccosukee Indian wearing tribal colors when he wrestles. It's the image people expect to photograph to symbolize the Everglades. Open 9–5 daily; 305-552-8365 or www.miccosukee.com/index.html.

Pro Tips: Before paying to enter the Miccosukee village, verify the day's alligator wrestling schedule, and that there is such a show. A shutter speed of at least 1/500 will capture all the gator action. For the craftspeople, bring strobe or tripod to enhance the natural light coming through the open sides of their stands. In the

A wide-angle close-up of traditional Miccosukee patchwork

museum, where most objects are behind glass, place your strobe (preferably detached) at an angle to the subject. That should remove any flash glare. If not, move more to the side and tighten on your subject. Glare appears more often in a wide-angle lens.

Following the Miccosukee Indian Village is Chief Osceola Airboat Rides.

OPTION 1: SOUTHERN LOOP ROAD TO BIG CYPRESS VISITOR CENTER

The Big Cypress Preserve's Southern Loop Road was to be part of the Tamiami Trail highway. It was almost complete when the route was changed to run farther north and follow its current direction. Also called County Road 94, the 26-mile pot-holed Southern Loop Road is the easiest way to venture into a large tract of untamed Glades wilderness.

Keep your camera ready, since you never know what may appear: gape-jawed gators beside or on the road, red-shouldered hawks perched in a tree, possibly the sudden appearance of a black bear or even a panther. They all live along this road. With the narrow lane as rough as the surrounding terrain, don't drive here in a vehicle with a low undercarriage unless you have spare parts for repairs. Depending on conditions, expect to spend 60 to 90 minutes to drive the loop road, which ends at US 41. Once on US 41, it takes another 25 minutes to backtrack east to the Big Cypress Visitor Center. *Option 2* (below) will get you to the visitor center much faster but without the same photographic possibilities.

Tree Snail Hammock Trail (47)

Watch for the Loop Road Scenic Drive on the left (actually, almost straight) when US 41 veers off to the right at 40 Mile Bend. This turnoff should be easy to spot since it's about the only sharp turn US 41 ever makes. The first scheduled Loop Road Scenic Drive stop is Tree Snail

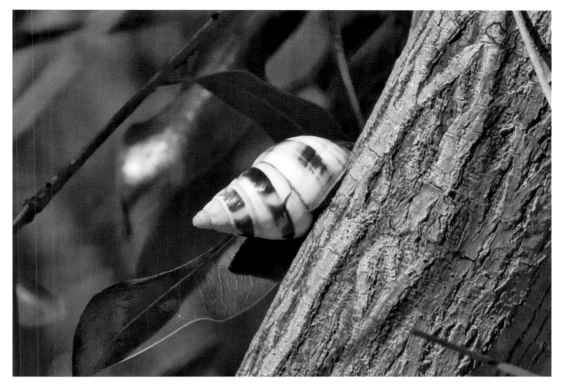

Because of the way the colors run together, the shell of a Liguus tree snail often looks out of focus even though it's sharp.

Hammock Trail, populated with good numbers of the usually difficult-to-locate *Liguus* tree snails. Bring a strobe and/or tripod and a good pair of eyes; sections of the trail can be quite dark. *Liguus* tree snails, only 2 to 3 inches long, live only in the tropical hardwood hammocks of South Florida and the Keys. Often referred to as living jewels, they come in 52 distinct shell color patterns ranging from bright white to black, all wrapped in whorls of pink, green, chestnut, or yellow. A species of special concern, *Liguus* snails are illegal to collect.

Pro Tips: Depth of field is a problem with this small creature if you're without a tripod or using a telephoto lens for a close-up. When a snail is within easy reach, I sometimes favor a wide-angle lens placed within inches of the snail with an off-camera strobe angled over it. In checking the shell's sharpness in the camera, don't freak. The shells never look to be in proper focus because of the way the colors seep into each other without sharp definition. *Never move the snails* to better light. In the winter dry season they go into a kind of hibernation, fastening to a branch and sealing their shells with mucus to keep from drying out. If torn from the branch, the snails will dry out and die.

Florida Trail Southernmost Trailhead (48)

Almost midway on Loop Road is the Florida Trail Southernmost Trailhead, one end of the Florida National Scenic Trail, one of only eight scenic trails in the U.S. About 1,800 miles are included in the Florida Trail system with the

hikes offering one of the best ways to photograph in Florida's wilderness—except here where the terrain is low. The path is almost always wet, with water sometimes knee- or even waist-high.

Sweetwater Strand (49)

Before too much longer, Loop Road turns sharply to the right, entering Sweetwater Strand, a low section where water often flows over the road and alligators may challenge you for the right of way. If for some strange reason you feel compelled to wade in the water in order to photograph, check the area first for snakes. I normally frame what I need from my vehicle.

For instance, if I see a gator worth a few frames, I angle my vehicle diagonally across the road to photograph out my window, which is always open on this road unless it's raining or the mosquitoes are too hellish. Besides alligators, Sweetwater Strand should offer you many photogenic areas of cypress swamp. Yes, cypress swamps can be attractive, particularly in fall, when the needles of bald and pond cypress turn a bright, coppery orange.

Monroe Station (50)

The road eventually rejoins US 41 at Monroe Station, a gas station built during the earliest days of the Tamiami Trail. On the National Register of Historic Places and now boarded

Monroe Station, a gas station that dates back to the first days of the Tamiami Trail, taken through the chain link fence surrounding it.

up with a high fence around it, the old wood building is a challenging photo subject. A ladder or footstool would certainly help. Supposedly the old place will someday be restored to become a National Park Service office.

Monroe Station Ponds/Rookery (51)

Leave your vehicle in Monroe Station's huge parking area to cross US 41 to what I call the Monroe Station ponds/rookery, a large gathering of herons and egrets accessible through an off-road vehicle (ORV) gate. Due to the racket ORVs make, the birds may be skittish at the sight of you. Close-ups may be difficult but still you should able to illustrate overall what a bird rookery is.

To reach the Big Cypress Visitor Center (52) afterwards, turn right on US 41 and go east, back toward Shark Valley. The visitor center is on the left. (See more below)

OPTION 2: TAMIAMI TRAIL TO BIG CYPRESS VISITOR CENTER

If you stay on US 41, bypass the southbound Loop Road Scenic Drive and go directly to the Big Cypress Visitor Center, you'll reach it in about 30 minutes; *Option 1* may take more than two hours due to poor condition of Loop Road and the need to backtrack.

Staying on US 41, the Clyde Butcher Gallery is not a stop for picture taking but for picture appreciation, an excellent stop for gaining new insight into the Glades landscape. Clyde Butcher is probably the most famous Everglades photographer, specializing in black and white fine art photography. Besides visiting the gallery, you may discover Clyde is giving a lecture or leading a swamp walk. Contact: 239-695-2428 or www.clydebutcher.com.

Big Cypress Visitor Center (52)

Big Cypress Visitor Center is a welcome oasis for a rest stop, a cold drink, and the latest information about the preserve. Between mid-

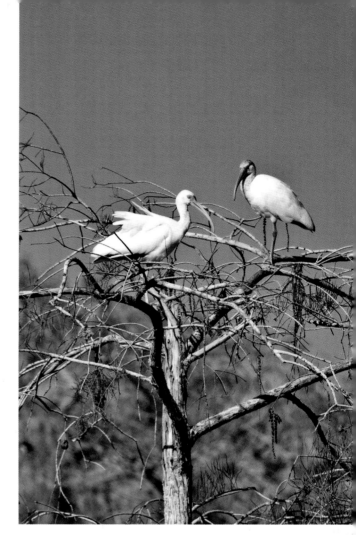

White ibis at Monroe Station rookery

December and mid-April, rangers lead guided walks into different sections of the preserve almost every day; check the schedule online. Be sure to stop at the boardwalk overlooking a canal in front of the building. You may have the luck I enjoyed one afternoon, when three gators repeatedly tried to snatch fish also residing in the canal. They kept trying for more than an hour, and then returned to masquerading as fallen logs. Contact: 33100 Tamiami Trail East, Ochopee, FL 34141; 239-695-1201 or www.nps.gov/bicy.

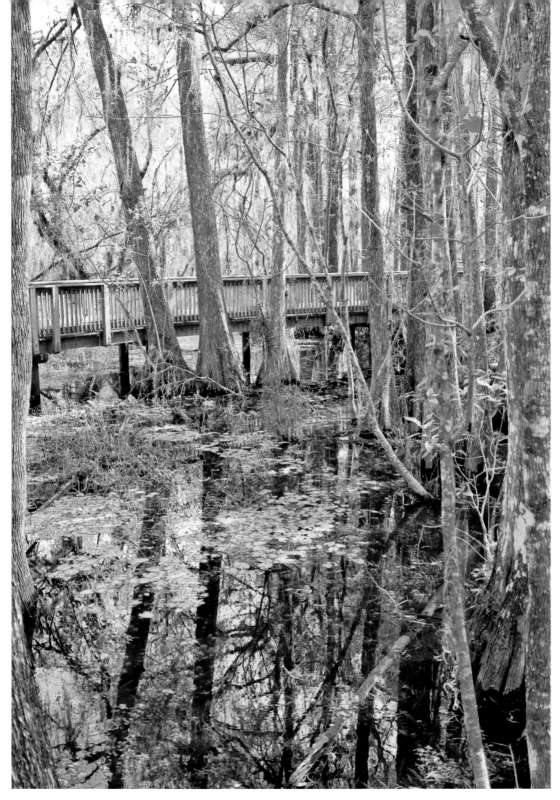

The boardwalk at Kirby Storter Roadside Park

VI. Big Cypress to Everglades City

General Description: More opportunities to explore Big Cypress's roadside canals, hardwood hammocks, cypress swamps, and grassy plains by foot, canoe, and another scenic drive.

Directions: From the Big Cypress Visitor Center continue west on US 41 to the junction with FL 29, which leads to Everglades City.

Kirby Storter Roadside Park (53)

Kirby Storter Roadside Park, 8 miles west of the Big Cypress Visitor Center, isn't very impressive at first glance. A boardwalk meandering into the distance looks like an uncomfortable, hot walk over open saw grass. Don't be deceived. The boardwalk quickly enters what I consider one of South Florida's most photogenic cypress swamps, with inhabitants including songbirds, gators, and deer.

This site is outstanding regardless of the sun's angle, especially midday, when the sunlight filters through the thick tree canopy or illuminates a series of small, open spaces. If you're here for sunset, immerse yourself in the mysterious night sounds of the Everglades.

Pro Tip: A strobe and tripod are good tools to have in the swamp anytime.

H. P. Williams Roadside Park (54)

Not far from Kirby Storter Park, US 41 intersects Turner River Road. Make a right turn to arrive at H. P. Williams Roadside Park, which features a short boardwalk on the banks of the fast-flowing Turner River. On the opposite shore is a stand of tall cypress usually well populated by wading birds of all types, as well as anhinga and osprey and sometimes even the odd-looking wood stork. That large, long-legged, white wading bird grows to almost

Where: On US 41 going west from the Big Cypress National Preserve Visitor Center

Noted for: Excellent birding areas, swamp boardwalks, nation's smallest post office, more airboat rides, and a wild animal zoo

Best Time: Winter dry season, when heat and humidity are at their lowest

Exertion: Minimal

Peak Times: December through March

Facilities: Extremely limited until Everglades City area

Parking: Designated parking lots and on roadsides if there is enough room and the ground is not mushy

Sleeps and Eats: Restaurants are limited in Ochopee. Everglades City has the closest motels and best selection of restaurants but no real fast food outlets.

4 feet tall and is the only wood stork breeding in the U.S.

Williams Park is best photographed early and late, when the birds are most visible. At midday they abandon the sunny open branches and move deeper into the cypress swamp, obscured behind the trees. I prefer the afternoon light here because it shines more directly on the birds.

OPTION 1: TURNER RIVER, UPPER WAGON-WHEEL, AND BIRDON ROAD LOOP DRIVE

When you parked on Turner River Road at Williams Roadside Park, you technically began the 17-mile Turner River, Upper Wagonwheel, and Birdon Road Loop Drive, Big Cypress Preserve's second scenic drive. A detour onto this lengthy trail is definitely worthwhile considering the numbers of birds you should spot and the accompanying plethora of alligators.

This also is perhaps the most sure-fire chance to photograph another iconic Everglades symbol, the white swamp lily. It appears in several places along the route, including one huge field of the plants.

The Big Cypress Preserve has a good detailed description of the wildlife you may encounter along with a map: www.nps.gov/bicy/planyourvisit/scenic-drives.htm. Following are the best spots to find critters, places the general NPS guide doesn't include.

Turner River (55)

For the first few miles it's difficult to see Turner River due to thick brush. Chances for spotting animals such as deer or black bear are better in the pine forest on the left side of the road. After 2.7 miles, the brush clears out and Turner River and its birds and gators finally are observable for a considerable stretch. It closes off again until the more extended open areas at 3.5 to 3.8 miles and 5.8 to 6.3 miles.

At 3.3 miles a dirt road for off-road vehicles crosses over the river. As this side road crosses the Turner River you have the opportunity to photograph the length of the stream, both north and south, without any obstructions. Similar ORV roads appear again at 5.4 and 6.9 miles.

The Park Service says at 7.1 miles the official scenic drive turns left onto Wagonwheel Road (my odometer read 7.4). Unless you have unlimited time, follow that route. If you're in no hurry and curious to be really off the beaten path, drive another 13 miles on Turner River Road until it ends at Bear Island Campground. Deer, bobcats, and even a panther have been sighted in this northern part of Turner River Road; remember, it's all a matter of luck.

The Turner River

Fire Prairie Trail (56)

Past the Wagonwheel Road Turnoff, continuing straight on Turner River Road, finding wildlife remains a hide-and-seek affair because cattails block the river for much of the way. The saw grass plain on the left is often the better view. Fire Prairie Trail is on the left at about mile 13. Using an old fire road flanked by ditches at the start, the 5-mile roundtrip walk goes past several cypress domes and a small hammock before moving into open prairie where white-tailed deer are common.

Back on Turner River Road, at 18.5 miles

you pass *under* I-75. There is no access road to the interstate highway but you'd be surprised how many people believe there is. Bear Island Campground, popular with hunters and ORV drivers, appears at 20.3 miles. Typically outside of hunting seasons the site is usually deserted during the week. The Big Cypress Visitor Center has a map of the walking trail here.

Pro Tips: Nothing ruins digital photography more than dust on a camera's sensor. Fast-moving pickup trucks or SUVs trailering ORVs to Bear Island Campground often turn Turner River Road into a dustbowl, launching billowing clouds of dust in all directions. Anytime you spot such a dust storm, retreat to your vehicle, roll up the windows, and wait inside until the dust disperses.

Limestone Ridge (57)
At Bear Island Campground, turn back and go south on Turner River Road until you reach the junction with Wagonwheel Road on the right. Make the turn and you're back on the designated scenic loop road, where after a third of a mile you'll see limestone rock lodged in the tall grass bordering the canal on the right. This is a wildlife viewing site I've dubbed Limestone Ridge. From this point on wading birds should become more frequent along with numerous white swamp lilies, a photo favorite. However, we're not the only ones who appreciate the flowers. The lilies also happen to be a deer delicacy.

Cypress Bird Pond (58) and Swamp Lily Field (59)
In about 1.5 miles is a small Cypress Bird Pond that attracts wading birds, though the birds tend to be skittish unless you approach slowly and noiselessly. In another 3 miles Wagonwheel Road veers off to the right, leaving you to finish the loop drive on Birdon Road. Where

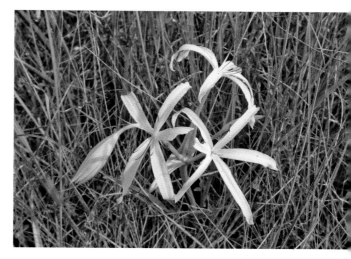

A white swamp lily in a field near Wagonwheel Road

Wagonwheel Road turns right, look for an amazing swamp lily field on the left side of Wagonwheel Road. The grassland there can be quite wet and unapproachable. This is the last major landmark until the loop road ends on US 41 directly across from Dona Drive Campground (61), described below.

OPTION 2: REMAIN ON TAMIAMI TRAIL
Turner River Canoe Trail (60)
Leaving H. P. Williams Roadside Park (54), continue west on US 41 for a half-mile to another small wayside park, on the right. This is a major launching point for canoe or kayak paddling for a 10-mile section of the Turner River Canoe Trail that ends at Chokoloskee Island. Rightly regarded as one of the best canoe trips in the Everglades, a trip on the scenic Turner River puts you eyeball to eyeball with wading birds and alligators as air plants fill many overhead tree branches. This river trip is one of the few chances to photograph a manatee or sea cow. You can rent a boat from one of the canoe/kayak outfitters in Everglades City or Chokoloskee Island.

Canoeing near the Dona Drive Campground

Dona Drive Campground (61)

Dona Drive Campground, directly across from Birdon Road, charges for camping but not to drive its short road ending at an open marsh, canal, and wading birds. This road is on a narrow jut of land between two canals where a gator could crawl out at anytime.

Next stop on US 41 is the Skunk Ape Research Headquarters, about 4 miles east of the junction with FL 29. Skunk Ape HQ's goal is to prove the existence of a 7-foot-tall, 450-pound ape-like creature Floridians have reported seeing for a hundred years. This is the Everglades version of Bigfoot, only a lot smellier, hence the "Skunk" Ape.

Ochopee Post Office (62)

Another mile on US 41 leads to the famous Ochopee Post Office, at 8 feet deep by 7 feet wide, it's the smallest in the U.S. The tiny building was used as a storage shed until Ochopee's post office burned down in 1953. Once all of the stamps and envelopes were transferred, the old shed became the post office and it's been that way ever since. With the Ochopee population sometimes as low as 11 residents, the facility was more than adequate. Most of the business now is from the thousands of tourists who stop to send a card with the Ochopee postmark. Contact: 239-695-4131.

Pro Tip: Several low-hanging wires create a real distraction. Crop tightly. I like morning best, when you can include both the building and the historic marker sign in the same frame. Still, the afternoon has its appeal, too. The building is well lighted either time.

The Ochopee Post Office

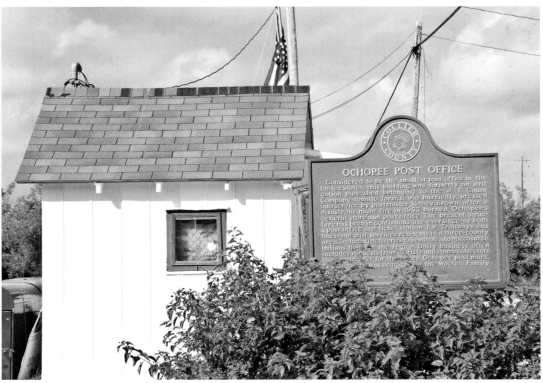

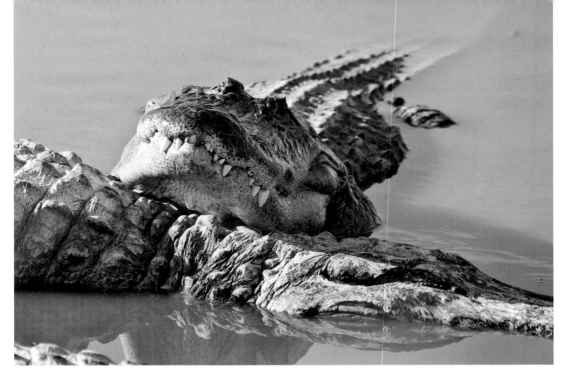
Alligators at Wooten's Everglades Adventure

Wooten's Everglades Adventure (63)

Shortly before the FL 29 turn to Everglades City is Wooten's Everglades Adventure, an area landmark since 1953. Noted mainly for its airboat and swamp buggy rides, I like Wooten's for its Alligator Park (200 gators, 27 American crocodiles) and its animal exhibit of bobcats, raccoons, an Asian tiger, and one of the largest snake collections in Southwest Florida. Although these animals are certainly worth hours of photography in their own right, my favorites are Wooten's beautiful Florida panthers. Unfortunately, getting quality images is difficult since the animals are behind double chain link fences due to many unbelievably stupid parents who—when there was just one chain barrier—encouraged their children to put a finger through the wire to touch an alligator or some other dangerous animal. I do have a *Pro Tip* (below) that will help make that fence wire disappear. Open daily 9–5, though hours do change seasonally. Contact: 1-800-282-2781 or www.wootenseverglades.com.

Pro Tip: Make the wire barrier seemingly vanish by placing your telephoto lens against an opening in the wire fence and focusing on a subject several yards away. You'll know immediately if the animal is too close when you look through the viewfinder; the fence will still be present, though blurry. Shaded fences disappear more easily than bright, shiny ones: A jacket or towel around a lens creates instant shade. When flash is needed, use a sync cord and a detached strobe unless you can place your camera and popup flash flat against the wire and both have an unobstructed opening.

Roadside Ponds (64)

The final stop before US 41 intersects with FL 29 are Roadside Ponds where you should find more birds to photograph.

VII. Everglades City/10,000 Islands/ Chokoloskee

General Description: Everglades City is the gateway to the 10,000 Islands entrance of Everglades National Park, which contains one of the Western Hemisphere's largest stands of mangrove forest. The mangroves make South Florida's Gulf Coast a crucial nursery for many of Florida's game fish, crabs and lobsters.

Directions: Turn left at the junction of US 41 with FL 29. Everglades City is a short distance ahead.

Commercial fishing, which started in Everglades City in the 1930s, still remains strong in the self-proclaimed "Stone Crab Capital of the

Some of the Barron River fishing fleet's stone crab traps

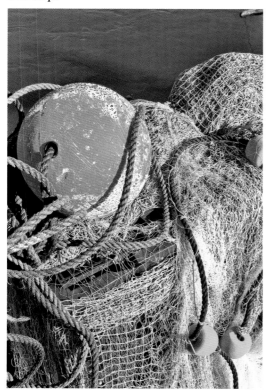

Where: On FL 29, south of US 41

Noted for: More airboat rides, commercial fishing, historic buildings, entranceway to Everglades National Park's 10,000 Islands Gulf Coast section

Best Time: Winter dry season, when heat and humidity are at their lowest

Exertion: Minimal

Peak Times: December through March

Facilities: Everglades City has them all covered.

Parking: Designated parking lots and on roadsides if there is enough room and the ground is not mushy

Sleeps and Eats: Easily available for the first time since Homestead/Florida City

World." Traditional fishing trawlers, however, increasingly share the city waterfront with professional sport fishing guides, bait and tackle shops, and public boat ramps.

Barron River Fishing Fleet (65)

A colorful place to capture the town's fishing heritage is along the Barron River. The best time is early morning when the boats depart and the soft sun highlights the details of the stone crab pots and their floats. This is also a good time to photograph the quirky, fanciful designs on the seafood restaurants. Start the drive by turning from Collier Avenue (the main street) onto Camellia Street to School Drive on the Barron River. Zigzag onto the different streets hugging the waterway.

Everglades Rod & Gun Club (66)

Going south along the Barron River brings you to the historic Everglades Rod & Gun Club, one of those rare Old Florida treasures with dark brown wood, pecky cypress paneling, and

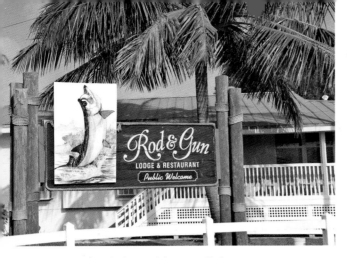

Everglades Rod & Gun Club

walls decorated with mounted grouper, tarpon, deer heads and gator hides. The hotel, dating back to 1864, was a private club in the 1920s and '30s and later attracted such guests as Presidents Truman, Eisenhower, and Nixon, Supreme Court Justice Warren Burger, and that most rugged of outdoorsmen, actor John Wayne. Today, the hotel is open to all, and if you want interior photographs, order something in the restaurant and feel free to shoot before and after your meal. Exteriors are best shot in the morning. Contact: 239-695.2101 or www.evergladesrodandgun.com.

Old Bank of the Everglades (67)

From the Rod & Gun Club go left (east) on West Broadway toward the heart of town. Directly opposite the club is the Old Bank of the Everglades with its imposing white columns and impressive size. It recalls the heady era after the Tamiami Trail opened and Everglades City saw itself growing into a Gulf Coast version of Miami instead of the quiet town it is. The impressive building, which has not served as a bank for years, has endured several failed attempts to turn it into a spa or a B&B. Closed; exterior shots only; afternoon is best.

Museum of the Everglades (68)

Almost diagonally across from Old Bank of the Everglades on West Broadway on the left is the Museum of the Everglades, a brightly decorated building opened in 1927 as a commercial laundry for workers building the Tamiami Trail. It closed during World War II and had a checkered history until becoming a museum in the 1990s. Exhibits detail 2,000 years of local history, but the building is your main subject, best shot in the afternoon. Open 9–4 Tuesday through Saturday. Contact: 239-695-0008 or www.colliermuseum.com.

Old City Hall (69)

Go a short distance on West Broadway to Old City Hall, located on the left at what's locally called Broadway on the Circle (a rare Florida roundabout). Built in 1928 in the style of an old Southern plantation great house, the impressive white-columned building was the county courthouse for all of Collier County. But in 1960 Everglades City, elevation only 3 feet, was severely damaged by Hurricane Donna, whose 175 mph winds caused tides 3 to 7 feet above normal. Collier County quickly moved its major government offices 30 miles away to East Naples.

The town used the building as its city hall until 2005, when Hurricane Wilma caused so much damage the structure had to be condemned. Restored to working order in 2007, the building is back to its postcard perfect condition, best photographed in the morning or at night (it's illuminated).

Gulf Coast Visitor Center (70)

From the Broadway circle, go south on divided FL 29 to ENP's Gulf Coast Visitor Center, a half-mile on the right. This ENP unit is a maze of mangrove islands, reaching all the way to Flamingo, which can be explored only by boat. The visitor center, with educational displays

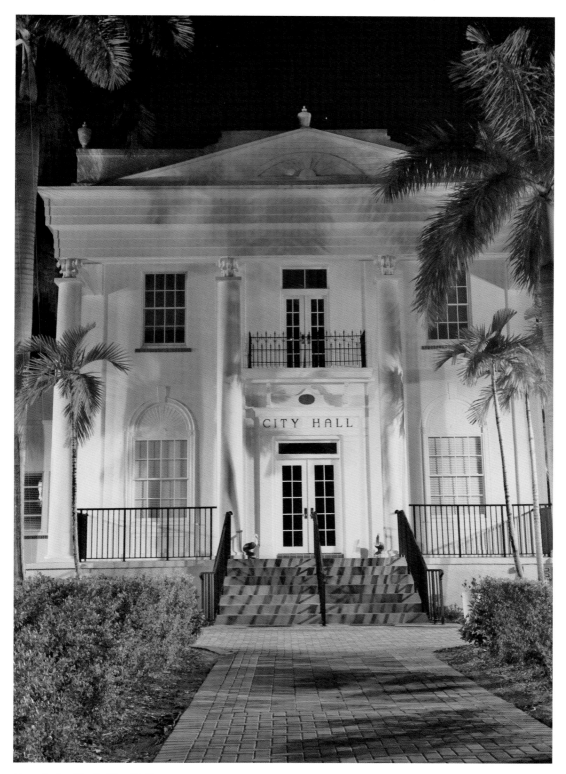

Everglades City's City Hall

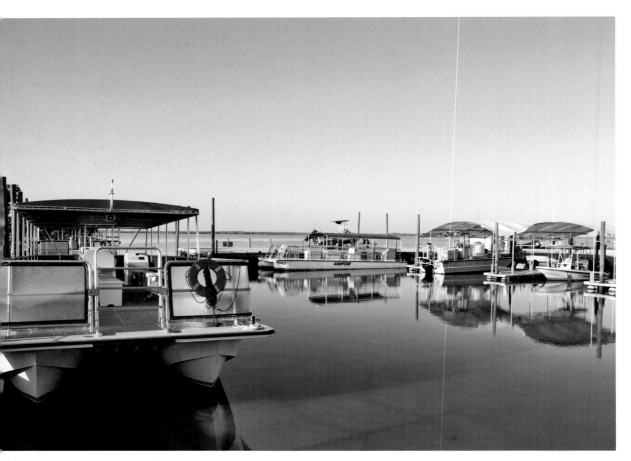

The marina at the 10,000 Islands section of Everglades National Park

and brochures, is a good place for bird photos (including pileated woodpeckers in the trees and around the pilings) before rangers and tourists start showing up. Open 9–4:30 daily. Contact: 239-695-3311 or www.nps.gov/ever/planyourvisit/gcdirections.htm.

10,000 Islands Boat Tour (71)

The 10,000 Islands boat tour features two very different tours. The mangrove wilderness tour is a leisurely substitute for a canoe trip up the Turner River (55) while the 10,000 Islands jaunt goes to the outer islands flanking the Gulf of Mexico. In addition, sunset cruises are offered from January through April. After taking

one of the cruises and getting a feel for the lay of the land, consider a rental canoe for your photography. Ospreys, manatees, roseate spoonbills, and even bald eagles are all likely subjects. Contact: 239-695-2591 or toll free 1-866-628-7275.

Observation Tower (72)

Across from the visitor center is an observation tower attached to a restaurant. Except for the huge observation tower at Shark Valley, this is the only place for photographing the Everglades from on high. Unfortunately, the restaurant and tower are closed in the morning. There is access only in the afternoon and

evening during restaurant hours. There's a small admission charge, but it's worth it if the sun is right.

Causeway to Chokoloskee Island (73)

You've now reached the end of Everglades City, ready to continue south on the causeway to Chokoloskee Island (FL 29). At low tide look for birds wading the mud flats close to shore. If tide and time mesh, this spot can be excellent for sunsets.

Historic Smallwood Store, Ole Indian Trading Post and Museum (74)

According to experts, Chokoloskee Island is actually a shell mound built by the Calusa Indians perhaps 2,000 years ago. You'd never know it based on all the modern development. The Historic Smallwood Store, Ole Indian Trading Post and Museum, a notable relic of the past, was built in 1906 for settlers needing everyday supplies, mail delivery, and a place to sell hides and produce. Situated on stout wood pilings well above floodwater, the store remained in business until 1982. An estimated 90 percent of its goods are now on display in the museum. On the National Registry of Historic Places; open 10–5 December through April and 10–4 May through November. Contact: 239-695-2989 or www.florida-everglades.com/chokol/smallw.htm. I like early morning for exteriors. The dark interior requires both strobe and tripod.

Low tide on the flats around the causeway to Chokoloskee Island

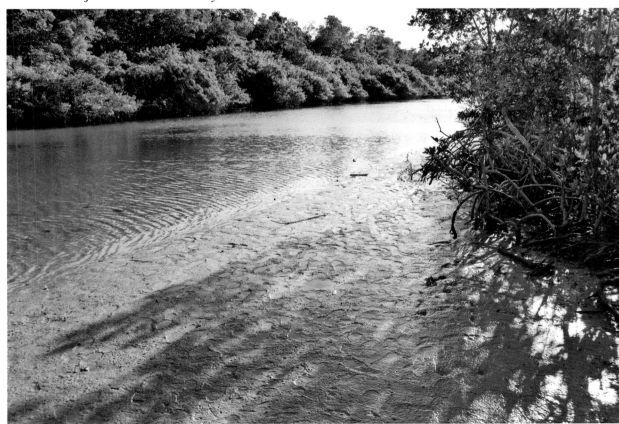

A wide-angle lens shows the length of a strangler fig wrapped around a cypress tree at Big Cypress Bend Boardwalk.

VIII. Everglades City to Collier-Seminole State Park

General Description: On the fringe of several large population centers on the Southwest Gulf Coast, this is still very much Glades country, with natural features you haven't encountered before. Much of this section (along with Chapter X) is dominated by the Fakahatchee Strand, a linear swamp forest 5 miles wide and 20 miles long. The shallow slough has its own climate, warmer in winter and cooler in summer than its surroundings. These ideal conditions make Fakahatchee the orchid and bromeliad capital of the continental U.S., with 44 native orchids and 14 native bromeliad species. This is also the realm of black bears, Florida panthers, and every conceivable type of Florida birdlife.

Directions: Follow US 41 west from FL 29 to Collier-Seminole State Park.

Roadside Ponds (75) and Big Cypress Bend Boardwalk (76)

Immediately after turning onto US 41 look for several roadside ponds, small bodies of water relatively close to the road that typically attract wading birds. From the ponds, it's about 6 miles before arriving at the Big Cypress Bend Boardwalk located in the southern section of Fakahatchee Strand Preserve State Park. Park in the small lot on the right before the Indian village. Follow the designated footpath for just under 300 yards to the 3,200-foot-long boardwalk, paying close attention to the canal on your right. It's a favorite haunt of river otters. Also listen carefully for the sound of woodpeckers in the swamp forest ahead. Some of my best pileated woodpecker photos were taken on the Big Cypress Bend Boardwalk.

The boardwalk leads into one of the world's few swamps where both royal palms and old growth bald cypress grow together, a remark-

Where: On US 41 going west after the FL 29 turnoff to Everglades City.

Noted for: Long boardwalk into a cypress swamp, a state park with exceptional Everglades history, hiking, and camping

Best Time: Winter dry season, when heat and humidity are at their lowest

Exertion: Minimal

Peak Times: December through March

Facilities: Scattered along US 41

Parking: Designated parking lots and on roadsides if there is enough room and the soil is not mushy

Sleeps and Eats: There are small restaurants here and there. Marco Island is the next major hotel/motel site, although it would be more convenient to use Everglades City for your base.

able tree canopy like few others. Note the huge strangler figs embracing several of the trees. And don't overlook the alligators so common here or the bald eagle's nest occupied since 1991. In terms of wildlife, this can be a very lively place. Contact: 239-695-4593 or www.floridastateparks.org/fakahatcheestrand.

The next stop is another Florida state park, the 7,271-acre Collier-Seminole State Park; it provides enough photo opportunities to occupy half a day or more. It contains one of only three native stands of royal palm trees in Florida, along with the typical hardwoods, cypress swamp, and coastal mangroves. Contact: 239-394-3397 or www.floridastateparks.org/Collier-Seminole.

Bay City Walking Dredge (77)

Now that you're nearing the end of the Tamiami Trail at Collier-Seminole, you encounter a

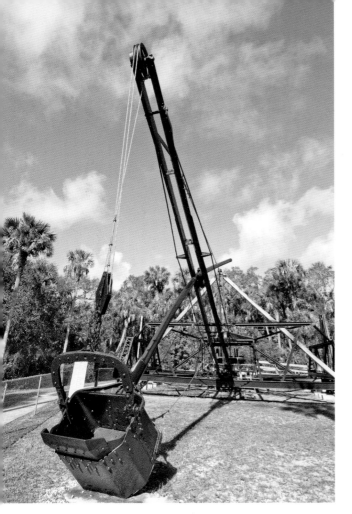

It took a 12mm lens to capture all of the Bay City walking dredge.

giant piece of equipment used to build the highway. Located in a fenced-off area just beyond the park entrance is the last remaining Bay City Walking Dredge, an odd-looking machine built in 1924 that could travel in wet Glades conditions when other vehicles on wheels or tracks would bog down. Use your widest lens (a fisheye would be good) to take in this monstrously large machine, a National Historic Mechanical Engineering Landmark; morning light offers the best shot. Put someone beside it for perspective.

Barron Collier Memorial (78)

From the dredge's parking lot, drive forward a short distance to where the road Ts. Turn left and park. Then follow the sidewalk to the next landmark, the white columns of the Barron Collier Memorial. Barron Collier helped finance part of the Tamiami Trail with the fortune he made in advertising. Florida's largest landowner, with 1.3 million acres, Collier wanted the road built to make his swampland more accessible. Collier-Seminole Park is a small fragment of his holdings.

Park Visitor Center (79)

The sidewalk continues ahead but is soon replaced by a dirt pathway leading to the Park Visitor Center located near the campground. With a first floor made of stone and a second floor of wood the building is similar to blockhouses built during the Seminole Indian wars. It commemorates the soldiers who fought in the Seminole Wars. The park name and a Seminole chickee replica elsewhere honor the only group of Indians never to sign a peace treaty with the U.S. government. The Blockhouse is another morning shot.

Royal Palm Hammock Trail (80)

The 1-mile loop path Royal Palm Hammock Trail begins at the western back end of the parking lot bordering the Black Water River. It enters an area with far fewer royal palms than the trail name would imply. Unfortunately, many were victims of lightning and high winds. The remaining royal palms are overshadowed by gumbo limbos and other common trees. You'll reach an observation platform about midway along the path, overlooking a saw grass marsh where wading birds often gather. The plant scenery is also well worth the short hike. In fall, the red berries of the Brazilian pepper brighten the trail; ironically these are an invasive species and slated for removal.

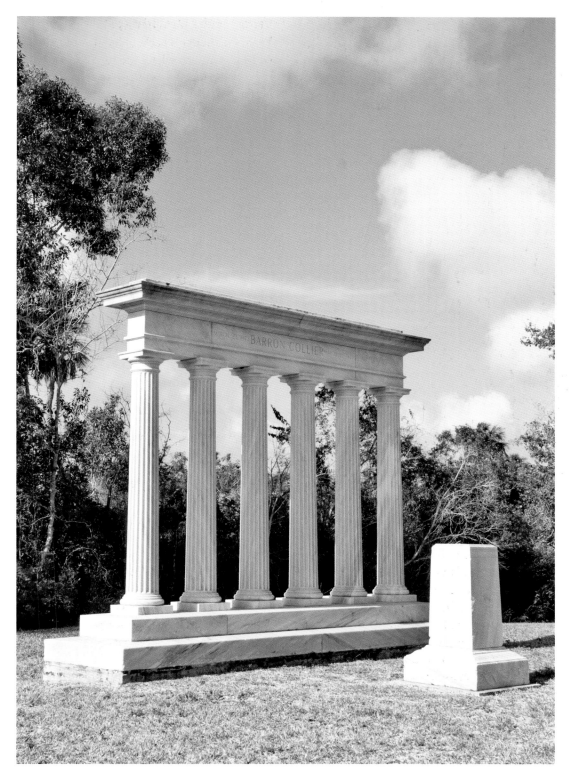

Barron Collier Memorial

Florida Trail (81)

If the brief Royal Palm Hammock Trail whets your appetite for more wilderness walking, consider the 6.2-mile section of the Florida Trail, located just 0.7-miles east of the main park entrance on the north side of US 41. If you're determined to see a bear or a panther in the wild, the trail's single primitive campsite puts you in a choice location. As this can be a wet walk, check at the park's main entrance station for conditions and to sign in before setting out.

Pileated Woodpecker

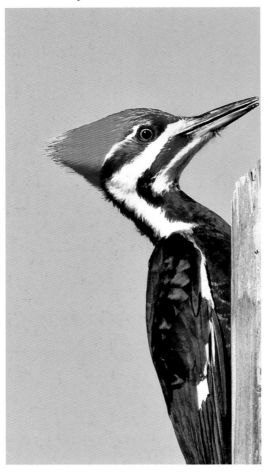

Black Water River (82)

The Royal Palm Hammock Trail faces the twisting 13.6-mile long Black Water River, a good place to launch a canoe and photograph

The blockhouse-style visitor center at Collier-Seminole Park

a scenic wilderness stretch. The partially signed canoe trail includes mangrove forest, several bays, and an open section of the Gulf. Tidal flow is an important consideration in how hard you have to paddle; plan to arrive at Mud Bay at high tide. The ranger station and canoe concessionaire have complete trip information.

Mangroves at Rookery Bay

IX. Collier-Seminole State Park to Marco Island

General Description: At first, typical Everglades roadside canals. Then onto two very different examples of Everglades settlement: The old fishing village of Goodland and the huge development of Marco Island. In Goodland, the architecture and waterfront are the main attractions. On Marco Island—here's a surprise—there are birds you haven't seen before, such as burrowing owls.

Directions: From Collier-Seminole State Park continue west on US 41 toward Naples. Turn left onto FL 92 toward Goodland.

Canals (83) and High Bridge (84)

The FL 92 canals flank the road leading to the southern end of Marco Island. Wading birds and alligators are the usual roadside subjects. Just before Goodland at what I call the FL 92 high bridge you'll drive high enough to see the condos and resort hotels of Marco Island 5 miles off to the right. This is a terrific spot for

Where: US 41, FL 92, and Marco Island
Noted for: Small, colorful fishing village, historic buildings, burrowing owls, shore birds, and coastal walking trails
Best Time: Winter dry season, when heat and humidity are at their lowest
Exertion: Minimal
Peak Times: December through April
Facilities: Marco Island has everything.
Parking: Designated parking lots and on roadsides if there is enough room and the ground is not mushy
Sleeps and Eats: Reaching Marco Island returns you to all the normal fast food delights, restaurants, and motel franchises. Too much culture shock? Everglades City is easy to drive back to.

aerial-like photos of the length of the Big Marco River, but there's too much traffic to stop on the bridge. Instead, you need to be dropped off. Shoot and then wave (or call) to be picked up.

Goodland

At the bottom of the bridge, be prepared for a sudden sharp left turn to follow the sign pointing to the tiny village of Goodland, founded in the 1800s. The first settlers reportedly built on a 40-acre Calusa Indian shell mound. Not hard to believe since much later, shells from Calusa mounds up to 16 feet high built a modern road to Goodland.

Stan's Idle Hour Restaurant (85)

The first photo stop is Stan's Idle Hour Restaurant, Goodland's famous Sunday party place, with music featuring the dance known as the Buzzard Lope; welcome to Everglades

Stan's Idle Hour Restaurant

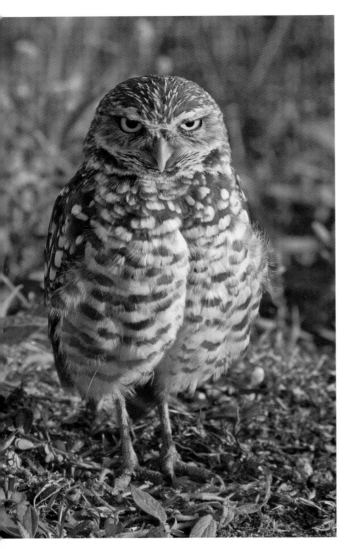

Burrowing Owl

colorful floats and stone crab pots. Kirk's is just yards from the Old Marco Lodge, built in 1869. The historic building was moved here in 1965, supposedly at a cost of over a million dollars, to save it from Marco Island's hectic building craze. Today it bears the name Old Marco Lodge Crab House and specializes in stone crabs and seafood. The back deck is a good place to take a sunset shot and shoot the parade of fishing boats on their way to the Gulf. Contact: 239-642-7227 or www.old marcolodge.com.

Marco Island

Burrowing Owls (88)

Marco Island was mostly untouched until the 1960s, when it was developed into one of the state's most popular Gulf resort areas. Despite extensive construction, it is also home to one of my favorite Florida birds, the remarkable burrowing owl. The only owl to nest under-ground, these tiny creatures (only 9 inches tall) are active during the day. Their sandy brown feathers flecked with white spots camouflage them surprisingly well—until their bright yellow eyes give them away. Most of the owls are accustomed to people and sometimes dig their burrows beside busy highways. Generally they don't mind one person approaching closely but may become skittish and fly off if another person joins you.

The owls have two characteristic poses. One is standing beside the entrance to their burrow. The second is sitting on a tiny wooden perch built for them. Approach the birds slowly and quietly with a telephoto and tripod and you should get some exceptionally good photos. Over a hundred burrows have been tallied. A GPS will lead you easily to this first location using this landmark: Ace Hardware, 1720 San Marco Road, Marco Island, FL, 34145.

"cultural happenings." Stan's is a photo-worthy subject for all of the decorations and the waterfront views. Contact: 239-394-3041 or www.stansidlehour.net.

Kirk's Seafood (86) and Old Marco Lodge Crab House (87)

Go past Stan's until the road Ts and turn left. Kirk's Seafood, also on the left, is the only good place outside Everglades City to photograph

Just a short distance west of the hardware store a colony of owls have been present on the corner of busy San Marco Road and Bahama Avenue for several years. From San Marco, turn onto N. Barfield Drive, go several hundred yards, and turn left onto Menorca Court. Owls are in a deserted lot here and in many other places in the neighborhood. Another reliable burrowing owl area is to the right of the entrance at Tigertail Beach (90) along Spinnaker Drive.

Marco Island Farmers Market (89)

The Marco Island Farmers Market offers a colorful display of organic vegetables, fresh seafood such as stone crab claws, locally grown citrus, and other fruits and freshly baked breads. But it's only open seasonally, 7:30–2 on Wednesdays from mid-November to the end of April at Mackle Park, 1361 Andalusia Terrace. Directions and latest information at www.marcoislandfarmersmarket.com.

Tigertail Beach County Park (90)

Located almost in the shadow of beachfront high-rises and surrounded by housing developments is amazing 31-acre Tigertail Beach County Park, at low tide one of the best birding places in Southwest Florida. It's been designated a critical wildlife area by the Florida Fish and Wildlife Conservation Commission; more than 86 different species of wintering, migratory, nesting and resident birds visit the park's tidal lagoon, shoreline mangroves, and uplands sections.

If it's not low tide during your visit, this won't be a productive place except perhaps for the occupied osprey platform to the right of the boardwalk leading to shore. If it is low tide, you'll find several types of shore birds feeding in the lagoon, oblivious to people and willing to let you get very close. These are varieties usually found near salt water, something you haven't really encountered before in the Glades.

Sand Dollar Island (91)

Across the tidal lagoon is Sand Dollar Island, a favorite spot locals wade to despite the muddy walk. A number of years ago the island was a mere sandbar but tide and wind have turned it into a much larger landfall. Sand Dollar, an important bird sanctuary, may have sections marked off-limits during nesting season. Directions: from Collier Boulevard on Marco Island,

Old Marco Lodge Crab House sign, stone crab traps

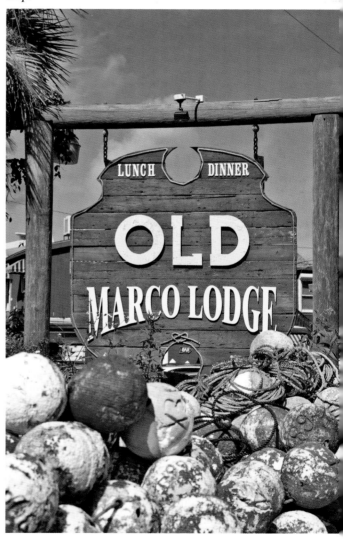

turn onto Tigertail Court, then left onto Hernando Drive. This ends at the park. Parking lot fee.

Briggs Nature Center Boat Tour (92)

Once again on Collier Boulevard, turn north toward US 41 and the Tamiami Trail. Look for Shell Island Road on the left and signs leading to the 110,000-acre Rookery Bay National Estuarine Research Reserve, a relatively undisturbed area containing pristine mangrove forest, uplands areas, and protected waters. Go for about 1 mile on Shell Island Road to the Briggs Nature Center Boat Tour on the right. Operated by the Conservancy of Southwest Florida, Contact: 239-262-0304, ext. 236.

Rookery Bay Walks (93)

From the Briggs Nature Center, follow Shell Island Road a short distance to where it ends at a boat ramp. Park here for the Rookery Bay Walks, a series of three trails, each about a quarter-mile long, known as "Trails through Time" with trailheads on both sides of the boat ramp. Facing the water, the Shell Mound Trail begins on the right, a somewhat difficult trail cut through tall grass without any hint about which path to take. No problem, you can't get lost wandering in the open area bordered by a mangrove shoreline. Inspect the ground. This trail, like the other two, is built on a single massive Calusa shell mound.

You may find better birding (including woodpeckers) in the tree canopy along Monument Trail on the left side of the boat ramp. The path leads to an old stone time capsule placed at the water's edge by 1960s high school students who helped raise funds to preserve Rookery Bay. Shortly before Monument Trail returns you to the boat ramp, look for the right turnoff onto Cat Claw Trail; it ventures through a hardwood forest with excellent views of black and red mangrove forests.

Shorebirds at Tigertail Beach

X. Everglades City North to Sunniland (FL 29)

General Description: Where Chapters 8 and 9 looked at stops after turning left off FL 29 and onto US 41 after leaving Everglades City, this chapter explores FL 29 as it continues north. It leads you into a remote section of Fakahatchee Strand Preserve State Park, which, like Collier-Seminole State Park, has one of Florida's most abundant stands of royal palms that grow alongside bald cypress. Fakahatchee's northern boundary adjoins the 26,400-acre Florida Panther National Wildlife Refuge, located in the heart of Florida panther country. With more than 700 plant species, Florida Panther NWR's other wildlife includes black bear, bobcats, deer, foxes, and even coyotes, whose population steadily increases in southwest Florida. You will be crossing I-75, so-called Alligator Alley, which you need to follow east to reach Big Cypress Seminole Indian Reservation (Chapter XII).

Directions: From the junction of US 41 and FL 29, go north on FL 29 to the town of Sunniland.

Roadside Ponds (94) and Janes Scenic Drive (95)

The roadside ponds on FL 29 shortly after crossing US 41 contain the usual cast of wading birds. Roughly 2.5 miles beyond US 41 is the most accessible area of the Fakahatchee Strand reached via Janes Scenic Drive. Turn left from FL 29 near the town of Copeland; you'll pass the main office of Fakahatchee Strand Preserve State Park before starting the drive. Check for current information and the latest wildlife sightings.

Although most of the Fakahatchee preserve is closed today, crews timbering cypress from 1944 to 1954 built an amazing network of tram

Where: On FL 29, north of US 41
Noted for: Scenic wilderness drive, hiking trails, roadside canals
Best Time: Winter dry season when heat and humidity are at their lowest
Exertion: Minimal
Peak Times: December through March
Facilities: Extremely limited between Everglades City and Sunniland
Parking: Designated parking lots and on-roadsides if there is enough room and the ground is not mushy
Sleeps and Eats: Everglades City has the closest motels and best selection of restaurants.

roads extending for 192 miles. They're now mostly overgrown, but several tram roads are kept cleared for hiking. The limited access is deliberate to protect the wood storks, bald eagles, Florida black bears, Everglades mink, and Florida panthers living here.

Moreover, the Fakahatchee houses the largest concentration and variety of orchids in North America, including the highly prized ghost orchid made famous in the book *The Orchid Thief*. The ghost orchid flowers in summer, and the park is happy to show off its prize specimens on wet, hot, buggy ranger-guided tours into the swamp. Far more relaxing is the 11.2-mile-long Janes Scenic Drive, a hard-packed dirt road that ends at Picayune State Forest. Passing through open prairie and thick cypress, this road is almost a guarantee for photographing deer, probably red-shouldered hawks, and definitely hundreds of air plants attached to the trees. Contact: 239-695-4593 or www.floridastateparks.org/fakahatcheestrand. A volunteer group, Friends of the Fakahatchee,

leads scheduled walks and canoe trips: http://friendsoffakahatchee.org/index.php.

I-75 Overpass (96)

Back on FL 29 going north, roadside metal fences and foliage make it difficult to see anything but birds roosting in trees, but do look for swamp lilies beside the road about 16.4 miles north of US 41. A half-mile later you're at the top of the I-75 overpass, not a bad place to be at sunrise or sunset for above, aerial-like photos of the Fakahatchee Strand to the south and Florida Panther National Wildlife Refuge to the north.

Florida Panther National Wildlife Refuge (97)

The only public entrance to the 26,400-acre Florida Panther National Wildlife Refuge is on the left about a half-mile beyond I-75. Until the hiking trail here opened, this land was as closed off as Fort Knox. High wire fences border the refuge along FL 29, not to keep people out but to prevent the endangered cats from running in front of traffic. Cars have killed as many as 14 animals in a single year. Panther numbers are minuscule, increasing from a probable 20 to 30 panthers 20 years ago to an estimated 80 to 100 today. They need all the protection possible.

The parking lot at Florida Panther NWR is huge, capable of holding school or tour buses, an indication of how many people want to see a panther in the wild. Your chance of photographing one of the cats is slim since they are most active at night and rest during the day. But you never know since between 5 and 11 different panthers use the refuge each month.

You have to enter and exit the 1-mile-loop hiking trail through a self-closing wire gate. The trail is often wet and may be closed due to high water. If not, enjoy the scenic walk through a hardwood hammock and pine flatwoods with good concentrations of wildflowers adjacent to the path. In keeping watch for a panther's appearance, remember the cat is misnamed, since panthers are normally black. The Florida panther is brown, actually a subspecies of the Western cougar though smaller and with a darker coat.

You could follow FL 29 to the town of Sunniland, passing roadside canals much of the way. This leisurely, enjoyable drive is recommended only if you have time to burn. Otherwise, leaving Panther NWR drive south to merge onto I-75 and go east to the Big Cypress Seminole Indian Reservation.

Taken through cage wires

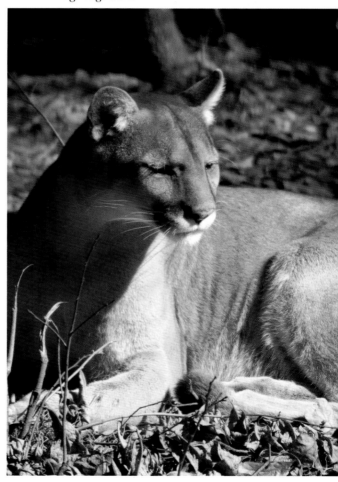

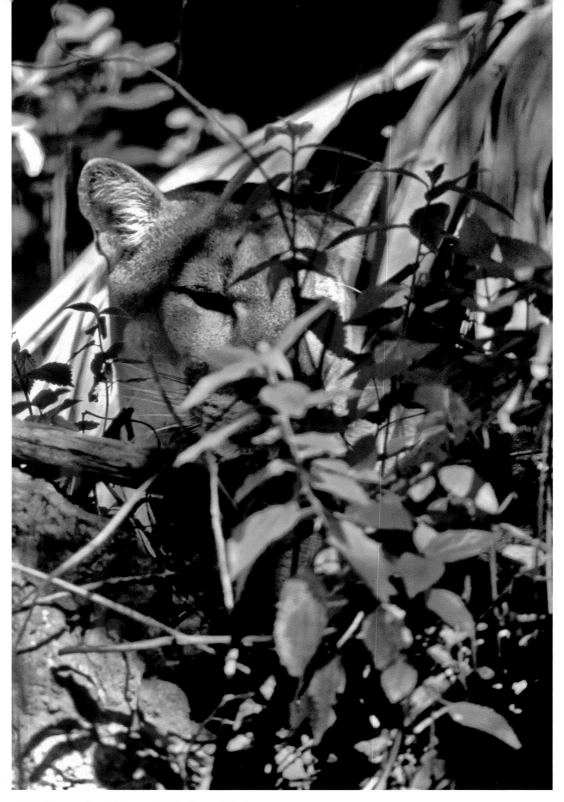

A Florida panther hiding at Billie Swamp Safari.

XI. Big Cypress Seminole Indian Reservation

General Description: This is the land of Florida's Seminole Indians, who, like the Miccosukee, were pushed into this swampland following the Seminole Wars. The Seminoles, descended from tribes in Georgia and Alabama, in the 1770s were called "runaways" or "wild people" when they moved into Florida. Technically, the Seminole Tribe of Florida did not exist before 1957. The tribe was created as a political organization in order to gain recognition, gain federal support, and make decisions affecting all tribal members. Traditionally a group that discourages contact with the outside world, the Seminole tribe operates several casinos. To the surprise of many, in 2006 the tribe purchased the Hard Rock Cafe chain of coffee bars, restaurants, hotels, and casinos operating in more than 36 countries. Contact: www.seminoletribe.com.

Directions: Follow I-75 east to Exit 49 and County Road 833, also known as Snake Road, Government Road, or BIA Route 1281.

CR 833 starts in the Miccosukee Indian Reservation, then runs through the Seminole tribe's Big Cypress Seminole Indian Reservation to the town of Immokalee. A large sign on the left marks your entrance to the 52,100-acre Big Cypress, largest of the Seminole's six Florida reservations but with a population of only 500. A significant part of the land is used for raising cattle, general agriculture, and growing citrus.

Roadside Canals (98)

Going north you pass a number of these impressive cattle and farming operations where deep roadside canals act like an extended moat, dividing them from the usually deserted road. The canals are a haven for alligators

Where: North of I-75 at Exit 49 on County Road 833, in the middle of nowhere **Noted for:** The relatively rare opportunity to witness Seminole culture. The Ah-Tah-Thi-Ki Museum displays many rare artifacts while telling the Seminole story. Billie Swamp Safari features airboat and swamp buggy rides and a café with Seminole foods. **Best Time:** Winter dry season, when heat and humidity are at their lowest **Exertion:** Minimal **Peak Times:** December through March **Facilities:** Limited after I-75 until reaching Billie Swamp Safari **Parking:** Designated parking lots and on roadsides if there is enough room and the soil is not mushy **Sleeps and Eats:** Sleep either in your own RV or in a thatch-roofed chickee, the traditional Seminole dwelling.

along with such wading birds as herons, wood storks, and egrets. Some canals contain a large green plant you probably haven't seen before: Water lettuce, also called swamp lettuce, a free-floating plant that can quickly cover a body of water, as some of these canals show.

Seminole Community (99)

After driving about 15 miles, the roadside becomes less deserted as more houses and a few stores start to appear. At about mile 17, just before you turn left to the Ah-Tah-Thi-Ki Museum (100) and Billie Swamp Safari (101), you encounter a cluster of large buildings including administrative offices, a school, and health centers. The buildings of this Seminole Community are brightly painted, irresistible

The Seminole camp at Ah-Tah-Thi-Ki Museum

subjects. Look for the colorful logos of the Tribal Council and Board of Directors. Both carry the same words found on U.S. currency: "In God We Trust."

The Seminoles are considered among the most traditional of the 560 tribes in the U.S., practicing such traditional beliefs as the "green corn dance" (closed to outsiders) and maintaining their own language. The Seminoles typically are shy and reclusive, somewhat understandable considering their history. After fighting three wars with the U.S. government, the Florida Seminole population fell from an estimated 5,000 in 1820 to only about 200 in 1858. The rest were killed or moved to reser-

vations in the Western U.S. Numbering fewer than 3,000 today, the Florida Seminoles never signed a peace treaty and take pride in being known as the "Unconquered Seminoles."

Pro Tip: Before photographing Seminole individuals, ask first. Many dislike being photographed. Show you are not the average camera-toting tourist by breaking the ice with their term for "hello": *Chi-hun-ta-mo*. If they agree to be photographed (hopefully in English), say "thanks" with *Sho-na-bish*.

Ah-Tah-Thi-Ki Museum (100)

"Ah-Tah-Thi-Ki" means a place to learn, and learning is one of the major roles of Big Cy-

press's Ah-Tah-Thi-Ki Museum; the museum's second function is to serve as a tourist attraction to draw more visitors. Unless a busload of German tourists is present, the museum staff usually allows tripods inside the museum but no flash due to the age of some artifacts. The museum contains dioramas of Seminole life in the 1890s as well as examples of silver work, the traditional patchwork clothing, and a dugout canoe.

This is also an outside museum with a mile-long elevated boardwalk through a 64-acre cypress swamp. Placards identify many of the 60 plants growing here, making photo IDs easy (simply photograph the card for reference). The boardwalk leads to the recreation of a small village with chickees and dugout canoes. Tribal members may be present to demonstrate how to make sweetgrass baskets, wooden carvings, and beaded necklaces. No guarantee. Call ahead to see if they are present. Ask about using flash in the gift shop. Open daily (except certain holidays) from 9-5. Contact: 863-902-1113 or www.ahtahthiki.com.

Billie Swamp Safari (101)

A few miles beyond the museum is Big Cypress's original tourist attraction, the 2,200-acre Billie Swamp Safari, the only place I know of where you can sleep in an authentic Seminole chickee, the traditional home made of palm thatch over a log frame. The Swamp Water Café is also a good place to try Seminole fry bread.

The safari is often a busy place, sending out airboat and swamp buggy tours and sometimes offering alligator and snake shows. It's disappointing most of the staff is not Seminole, and you may leave without photos of anyone wearing the traditional patchwork. Like most Indians, the Seminole have adopted cowboy wear and traded in their horses for trucks.

If this is your first Glades visit, try the swamp buggy, a monster truck on huge wheels that plows through fairly deep water. With open sides and a tarp roof, it's about as cool as a vehicle can be and it offers excellent freedom of camera movement. Besides traveling into cypress domes and hardwood hammocks, you have a virtual guarantee of photographing alligators and crocodiles, American bison and Southern razorback hogs, and perhaps even exotic deer and antelope. Yes, bison once roamed in Florida but never in these wetlands.

Spend the night and you can listen to Seminole legends around a campfire. A campfire constructed amazingly like those made in Africa. And the Seminole beadwork when compared to that of Africa's famed Masai and other tribes? To my semi-educated eye, they are eerily similar. Just another of the many things that keep drawing me back to the Everglades. Contact: 1-800-949-6101 or www.seminole tribe.com/safari.

Royal palm tree at Collier Seminole Park

Favorite Old Florida Locations

Historic Downtown Homestead
Ochopee Post Office, Ochopee
Barron River Fishing Fleet, Everglades City
Downtown Everglades City
Historic Smallwood Store, Ole Indian Trading
 Post and Museum, Chokoloskee

Favorite Scenic Locations

Kirby Storter Roadside Park, Big Cypress
H. P. Williams Roadside Park, Big Cypress
Sweetwater Strand, Big Cypress
Big Cypress Bend (Fakahatchee) Boardwalk
Ah-Tah-Thi-Ki Museum, Big Cypress

Favorite Hikes & Walks

Anhinga Trail, Homestead, ENP
Tree Snail Hammock Trail, Big Cypress
Big Cypress Bend (Fakahatchee) Boardwalk
Collier-Seminole Florida Trail Hike
Rookery Bay Walks
Florida Panther NWR
Ah-Tah-Thi-Ki Museum, Big Cypress

Favorite Sunset Locations

Dwarf Cypress, with sun behind, Homestead,
 ENP
Pa-Hay-Okee Overlook, Homestead, ENP
Rookery Bay Walks

Art Deco facade, Historic Downtown Homestead

Anhinga Trail at the Royal Palm Visitor Center, Everglades National Park

Favorite Wildlife Locations

Anhinga Trail, Homestead, ENP
Flamingo Marina, Homestead, ENP
Shark Valley West Road, ENP
Big Cypress Bend (Fakahatchee) Boardwalk
Burrowing Owls, Marco Island

Favorite Panoramic Locations

Pa-Hay-Okee Overlook, Homestead, ENP
Shark Valley Observation Tower, ENP
Collier Boulevard bridge leaving Marco Island
FL 29 I-75 overpass
County Road 833 I-75 overpass

Favorite Plant/Tree Locations

Gumbo Limbo Trail, Homestead, ENP
Dwarf Cypress, Homestead, ENP
Sweetwater Strand, Big Cypress NP

Big Cypress Bend (Fakahatchee) Boardwalk
Ah-Tah-Thi-Ki Museum, Big Cypress

Favorite Sunrise Locations

Main Road Bridge & Concrete Drain Pipes,
 Homestead, ENP
Dwarf Cypress, with sun behind, Homestead,
 ENP
Flamingo Visitor Center, Homestead, ENP
Flamingo Campground, Homestead, ENP
Collier Boulevard Bridge leaving Marco Island

Favorite Tourist Traps

Robert Is Here!
Coral Castle
Miccosukee Indian Village
Wooten's Everglades Adventure
Billie Swamp Safari, Big Cypress